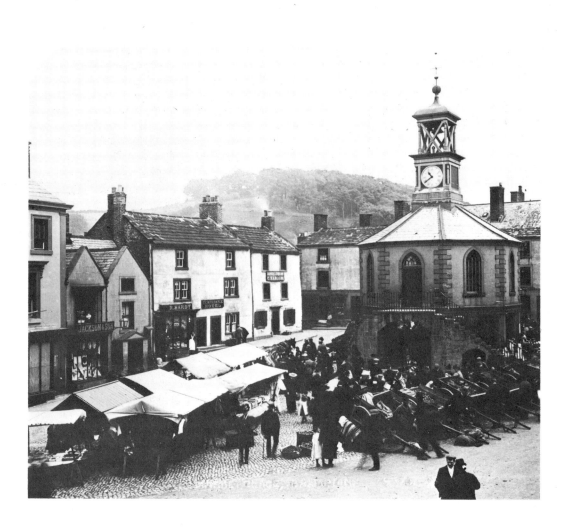

1 *Above* Brampton market place soon after 1900

2 *Following page* Looking north up Lake Windermere which froze in February 1895

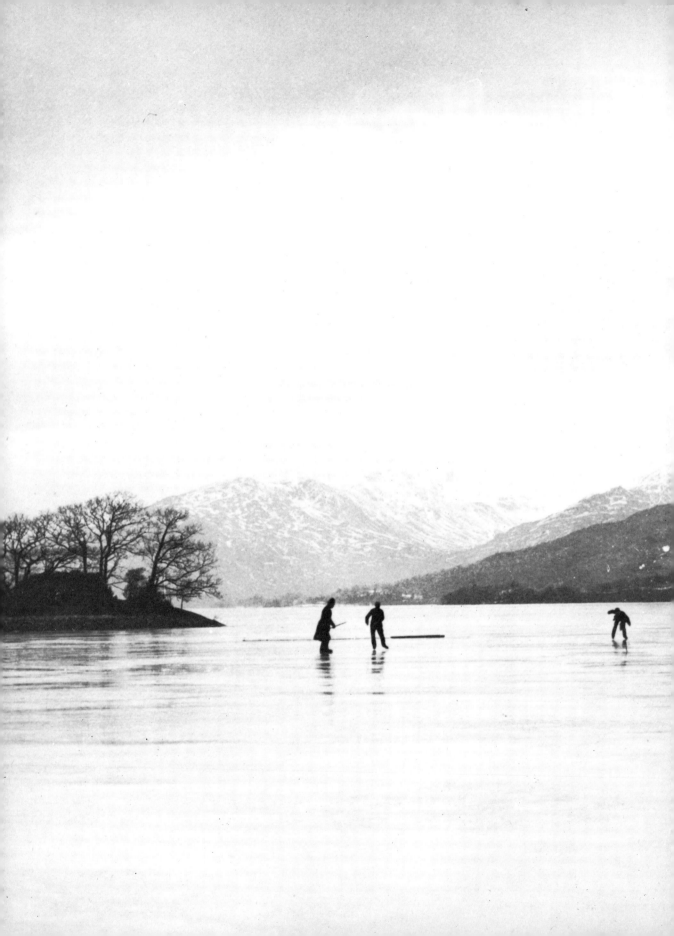

Victorian and Edwardian

LAKE DISTRICT

from old photographs

Introduction and Commentaries by

J. D. MARSHALL & M. DAVIES-SHIEL

B. T. BATSFORD LTD.
LONDON

First published 1976
© Text J. D. Marshall & M. Davies-Shiel 1976

Phototypset by Tradespools Ltd, Frome, Somerset
Printed in Great Britain by
The Anchor Press, Tiptree, Essex
for the publishers B. T. Batsford Ltd
4 Fitzhardinge Street, London W1H 0AH

ISBN 0 7134 3071 0

CONTENTS

ACKNOWLEDGEMENTS

This collection of photographs owes a great deal to the help and kindness of many people, some of whom originally lent prints to the University of Lancaster photographic collection for copying and preservation. We wish to thank the several librarians who helped us, not all of whom can be mentioned by name, and numerous owners of private photographs or custodians of collections. For the photographs reproduced here, the Authors and Publishers wish to thank: Ann Metcalfe-Gibson for Figs 148, 149, and 153; Mr Edwin Course, Southampton, for Fig. 4; Mr George Dodgson of Grange-over-Sands for Figs 3, 5, 6, 7, 31, 36, 49, 68, 144, 146 and 147; Mrs Ann Henderson of Aspatria for Fig. 133; Barrow-in-Furness Central Reference Library collection for Figs 8, 9, 27, 28, 29, 45, 48, 86, 95, 99 and 109; Mr Raymond Sankey of Barrow for permission to use the following, several of which are in the same collection, Figs 20, 30, 37, 72, 131, 141, 142, 143; the Record Office, the Castle, Carlisle, for Fig. 10, and the Farrer collection of photographs at the same for Fig. 57; Mrs Daphne Maclaren for Figs 11, 12, 13, 14, 15, 17, 18, 21, 93, 94, 96, 97 and 136; Messrs, F. Frith and Company Limited, the Mansell Collection and the Hepworth Collection (by arrangement with Mr Sam Carr and the Publishers) for Figs 16, 22, 24, 26, 46, 54, 55, 115, 124, 128, 129, 134 and 135; the Dalesman Press and Mr W. R. Mitchell for Fig. 23 and (by courtesy of Mrs S. Benson), 87, 107 and 108; the University of Lancaster Photographic Collection (from the University's set of Hardman photographs), Fig. 89; the Jackson Collection, Museum and Art Gallery, Tullie House, Carlisle, for Figs 64, 83, 110, 116, 117, 123, 125, 126 and 127; the City of Lancaster Reference Library for permission to use items from the albums of the late Sam Thompson, Figs 33, 38, 40, 53 and 148; the same Library for Figs 58 and 119; Miss M. Lawrie of Workington for Figs 34, 41, 47, 52, 56, 59, 67, 73, 85, 90, 92, and 132; Mr J. H. F. Spedding of Mirehouse for Figs 44, 78, 79, 80, 81 and 82; Mr J. J. Martin of Workington for Figs 71, 100 and 130; the Kendal and Westmorland Library for Figs 25, 35, 50, 63, 98, 105, 137 and 138; Mrs Winifred Inglesfield (by courtesy of Mrs Airey and Mrs W. Wilson) for Figs 84, 88, 119 and 120; the Rock and Fell Climbing Club (items from the Abraham Collection), for Figs 39 and 51; Mrs L. M. Wearing, for Fig. 150; Mr D. Thompson, for Figs 122, and 151; the Earl of Lonsdale for permission to use Figs 2, 32, 60, 61, 62, 69, 70, 74, 75, 76 and 77, mainly from family albums; Mrs M. I. Hawes for Fig. 144; Mrs A. M. Birkett for Fig. 118, and Mr J. Penny for Fig. 121.

We would like to thank, especially, for their help and information, Miss Lawrie of Workington (whose father's photographs give little indication of his stature as an ornithological photographer), Mr Alf Hemer of Lowick Green for his sage information on farming practices, and Mr Denis Perriam of Tullie House for making available some superb photographs; likewise, Mr Ron Smith of Barrow Library, Mrs Inglesfield of Natland, Mr J. H. F. Spedding for some precious family photographs and helpful information regarding them, and Lord Lonsdale for similar help and hospitality. It is only fair to add that Mr Davies-Shiel supplied Figs 102, 106, 112 and 113, and that Mr J. Thompson, the university photographer at Lancaster, performed much careful and patient copying of valuable prints on loan.

INTRODUCTION

The English Lake District has long attracted the professional photographer. Well over a century ago, the newspaper *The English Lakes Visitor* was advertising the studio of George Perry Abraham of Lake Road, Keswick, who made studies of "Tourist groups, and all other styles at lowest possible prices". The Abraham family, who recorded early local mountaineering history for posterity, and who helped in a very practical sense to usher in the motoring age, have left a fine collection of negatives and prints, some of which appear in this book. Yet there were many other photographers, amateur and professional, seeking their own kinds of truth – or clientèle – and numerous authors have brought to light the rich reserves of illustration which now serve to tell us about that now distant age of Victoria and Edward.

The pictures on their own do not always tell a story. The present authors, therefore, have tried to thread together the old photographs theme by theme, with as much basic explanation as may bring them to life or to the point. We commence, appropriately, with a visitor's eye-view of the approaches to the Lake District as they appeared 70 or 80 years ago, with a suitable emphasis on trains, stations, ferries, steamers and coaches. Then, having brushed off the dust or raindrops, we survey board and lodging, and begin to feel part of Lakeland observances, festivals and special occasions.

The browser will notice that, even at this stage, "Lakeland" is interpreted pretty widely. The typical tourist would not, of course, before the motor age, find himself in Workington; but he would meet Workingtonians, and the fact is that the fringe towns and districts of the Lake Counties were and are very much part of the mainstream of local life. The industrial towns of the west supplied wrestlers – like the great Steadman and Lowden – excursionists, climbers, walkers and photographers. Besides, not to include them in this book would be harmful to any notion of balanced social history. If we are to have views of the concourses of nobility and gentry which so impressed the local folk of two generations ago, then we must also give a view of West Cumberland miners on strike or collecting for charity. The other way lies the sweet-pickled romanticism which ends in mere folksiness. Let us look inside the typical Victorian farmhouse, or see a picture or two of Tommy Dobson, but let us also see how the rich dined in that lavish age, and show the domestics at work in a great house.

To include details of this kind has sometimes meant leaving the main tourist haunts. The history of the Lake Counties is something altogether wider than the story of beauty spots and their invasion. The visitor who is prepared to study the former will find his appreciation of the Lake District much increased, and the rest of the book ranges wide, over people and their work in town, fell and dale, over familiar scenes now often transformed, and over some marked (and subtle) social changes. The age of the horse, now at an end, is portrayed in some detail, but the motor car makes its appearance, and there is even an early flying machine. It will be noticed that the railways, which aroused the deepest mistrust in the breast of a Wordsworth, did little harm to the Lake District as we now know it. The motor vehicle seems to be a different matter.

The Lakeland hotels were providing coaching facilities well over a century ago, and when the Royal Hotel, Bowness, was sold in 1860, it advertised as part of its equipment "Sixteen Horses, Twenty-One Carriages, Three Omnibuses, Twenty-two sets of Double and Single Harness. . . ." Later on, the firm of Rigg took over much trade, but most of the larger hoteliers ran tours, and Harriet Martineau's *Guide* (popular at that time and afterwards) shows that regular services were operating through the main dales, and it is clear that the railways stimulated these. Our photographs of tourist transport belong, for the most part, to the end of the Victorian period or later, but the scene changed little in half a century. Life moved at the same pace, although the horses made much work for curriers, blacksmiths and harness makers. It is this leisurely world that the photographers caught so well, that other age before the catastrophe of 1914:

> *Never such innocence,*
> *Never before or since,*
> *As changed itself to past*
> *Without a word – the men*
> *Leaving the gardens tidy,*
> *The thousands of marriages*
> *Lasting a little while longer:*
> *Never such innocence again.*

Thus writes Philip Larkin*, who makes us feel, as we all must, for "The countryside not caring", "The differently-dressed servants", and "The dust behind limousines".

And what of these photographers? Not all were high or full-time professionals, like Edward Sankey, who commenced taking his photographs about 1903, and who came to print about 500,000 postcards of the Lake District and north-west annually at his Barrow works. His firm, which continued until 1970, left behind a superb collection, and numerous examples are in this book. His work, like that of the Abrahams is sometimes trademarked or overprinted. Other excellent Lakeland photographers have

*From *MCMXIV* by courtesy of the poet and Messrs Faber and Faber.

left us their creations only in the form of unmarked negatives, like those preserved by the firm of Jolyon Dodgson at Grange-over-Sands, and almost certainly including the work of the Misses A. and L. Slingsby, who occupied a studio on the Esplanade at Grange before the First World War. They may have produced some of the finest pictures in this volume, especially Nos 4 and 6. In other instances, the photographer identifies himself, like Sam Thompson of Lancaster, who took the unforgettable views of Troutbeck and the Kirkstone Inn in that snowy, cold Easter of 1913 (Nos 38, 40). In his case we have a rare view of the photographer in action (No. 53).

Another fine amateur, whose work is also represented in this volume (but not in this instance adequately, for he was one of the outstanding ornithological photographers in the north of England), was William Carruthers Lawrie (1885–1960) of Workington, who has left us the haunting studies of local miners (Nos 90, 92), the superb posed groups in Keswick and district (Nos 34, 41), and the early flying machine (No. 59). The work of others, alas, cannot be so simply identified, and there were, in any case, many professional photographers in the Cumbrian towns at the turn of the century – five in Workington, three in Maryport, nine in Carlisle and three in Cockermouth. In Keswick, even G. P. Abraham had competition from Henry Mayson and Alfred Pettitt. Southern Lakeland, too, had its equivalent of Abraham in Waters of Bowness, (who worked in early and mid-Victorian times) and in William Brunskill, an Edwardian photographer of distinction. Where individual photographers – not mentioned here – have been identified, this fact is made clear in the caption. Much research goes into the identification of painters and engravers of secondary importance, and it is a pity that past photographers of artistry and judgement cannot be resurrected from oblivion more often.

It remains to add that several of the outstanding photographs in this book come from national collections like those of Frith and Mansell, and that they were made available through the good offices of Sam Carr and Messrs B. T. Batsford. We have also, for good measure, included at least one photograph by that finest of camera artists, the late Joseph Hardman (who operated outside our period, but whose picture of Isaac Cookson was highly relevant to its themes), and at least one by the late Miss M. C. Fair of Eskdale who performed fine work with her camera just after the First World War. Her view of a bobbin worker at Santon Bridge demonstrates an operation that had not changed much during the preceding half-century (No. 110).

APPROACHING THE LAKES

3 *Below* This London and North Western Railway express, shown here on Shap Summit in about 1903, would have disgorged some of its Lakeland tourist passengers at Carnforth or at Oxenholme, thence to find their way by branch lines into the Lakes. The third class return fare London to Windermere (1884) was 37s.6d., a heavy burden for an artisan or labouring family. Hence, even when real wages were rising, the Lakes tended to be patronised by the "educated" groups, many of their members from the south of England. (Picture by courtesy of Mr Edwin Course, Southampton)

4 *Right* Numbers of such passengers would have taken the Furness Railway trains from Carnforth to Grange-over-Sands or Broughton-in-Furness. Here is a posed view of the entire staff of Grange Station in about 1904, probably taken by the Misses Slingsby of Grange. A large staff of porters awaited guests with plenty of luggage and change to spare for tips

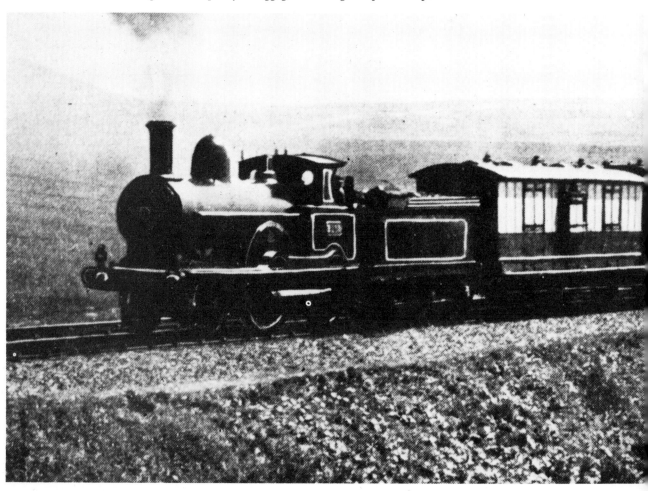

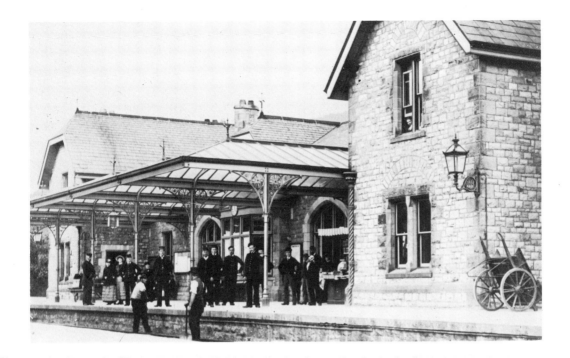

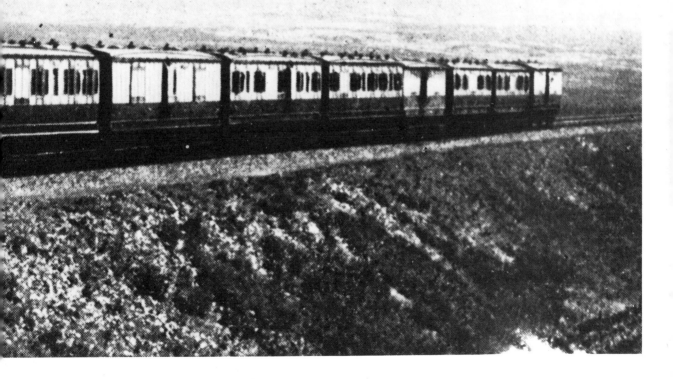

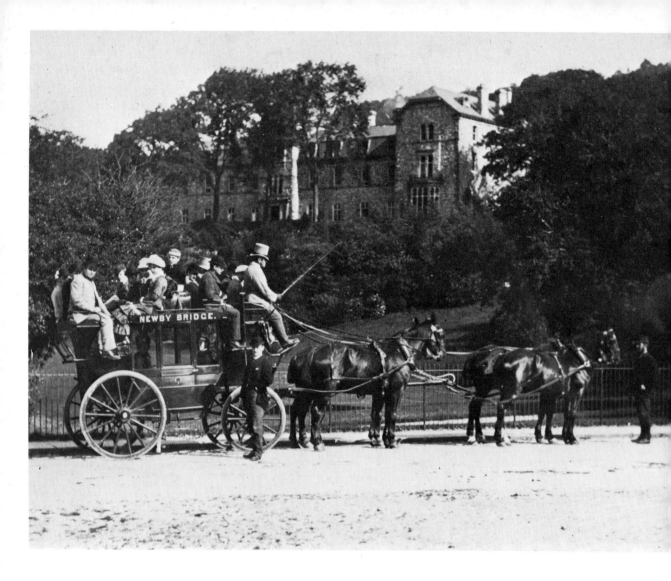

5 *Above* Behind the station, Thomas Rigg's coaches provided summer tours of the Lakes; the Grange Hotel (1866), seen in the rear, seems to have given the station its style. The coach with four fine chestnut horses, driven by Mr Purcell, in the top hat, gave access to Newby Bridge and Lakeside, from which point steamers were available

6 *Right* Morecambe Bay and the Kent Estuary attracted the bather and the boatman. This moment of windblown happiness from a vanished summer (about 1910) commemorates an age when shifting sands and river channel had not covered the foreshore with mud. Holme Island, near Grange, lies beyond the boats

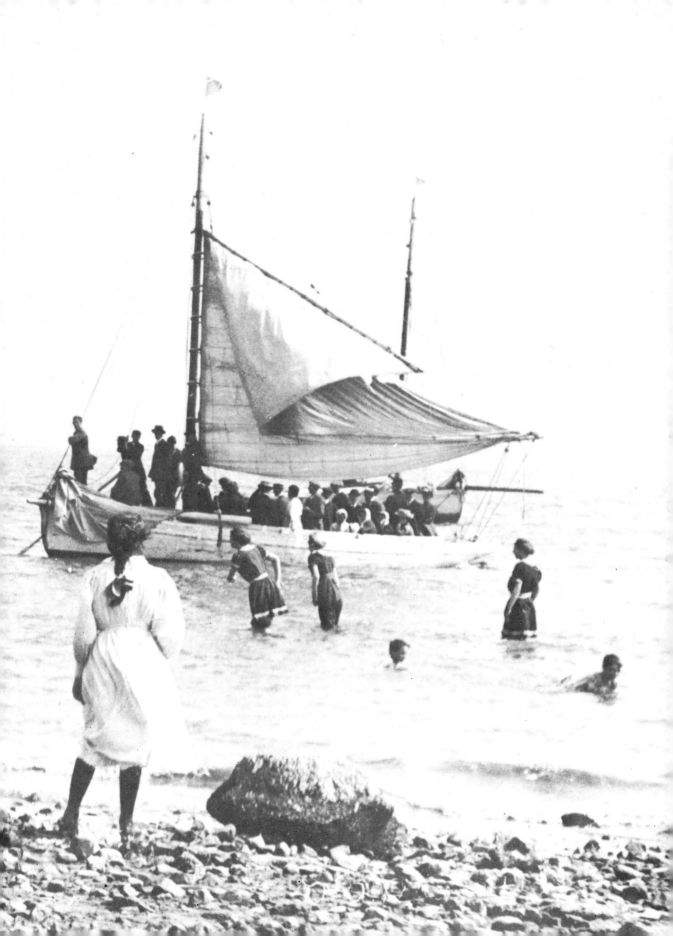

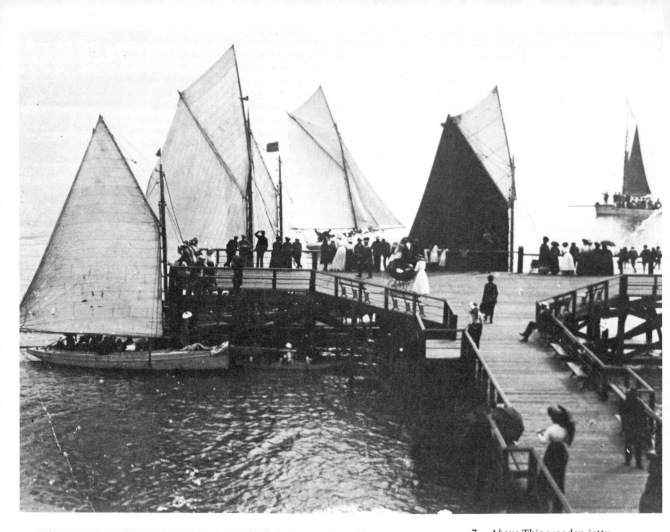

7 *Above* This wooden jetty, long ago washed away, stood near Berners Close, Grange, and was known as the New or Clare House Pier. It was built in 1893 for the cross-bay sailing vessels which brought visitors from Morecambe

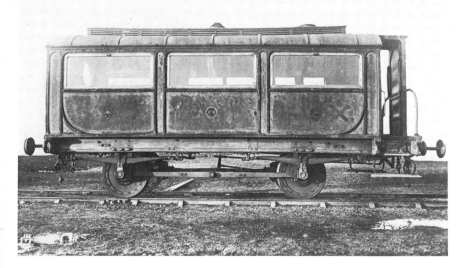

8 *Above* Railway passengers might have been intrigued by the sight of the private railway saloon, standing in its siding at Cark Station, provided for the Seventh Duke of Devonshire during his chairmanship of the Furness Railway in the mid-Victorian years. The same line, indeed, had the Duke's family motto, *Cavendo Tutus* (meaning, appropriately, 'Proceed with Caution!'), on its crest. Cark is the station for Holker Hall, and the Duke's entourage moved by private train between his respective seats

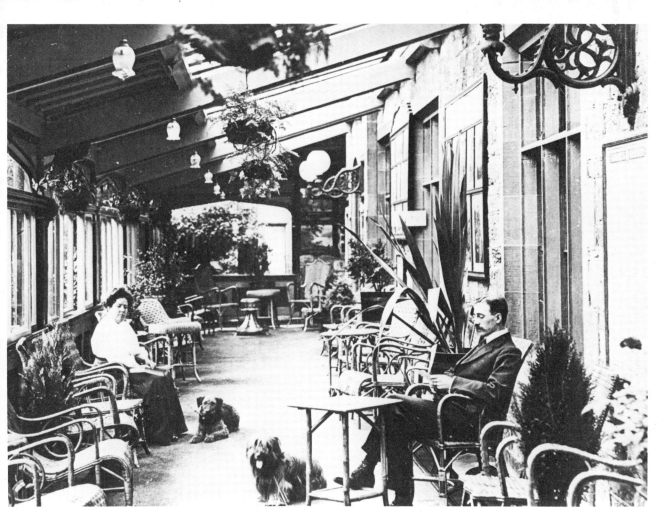

9 The Furness Abbey Hotel, another vanished landmark, provided solid comforts for the affluent visitor to Barrow who wished to avoid smoke and redbrick terraces. This advertisement photograph shows the verandah. Some Lakeland visitors came by steamer to Barrow, especially in early Victorian times, and the Furness Railway tried hard to capture tourist traffic in its later days. It was responsible for the hotel, which stood near the magnificent Abbey ruins

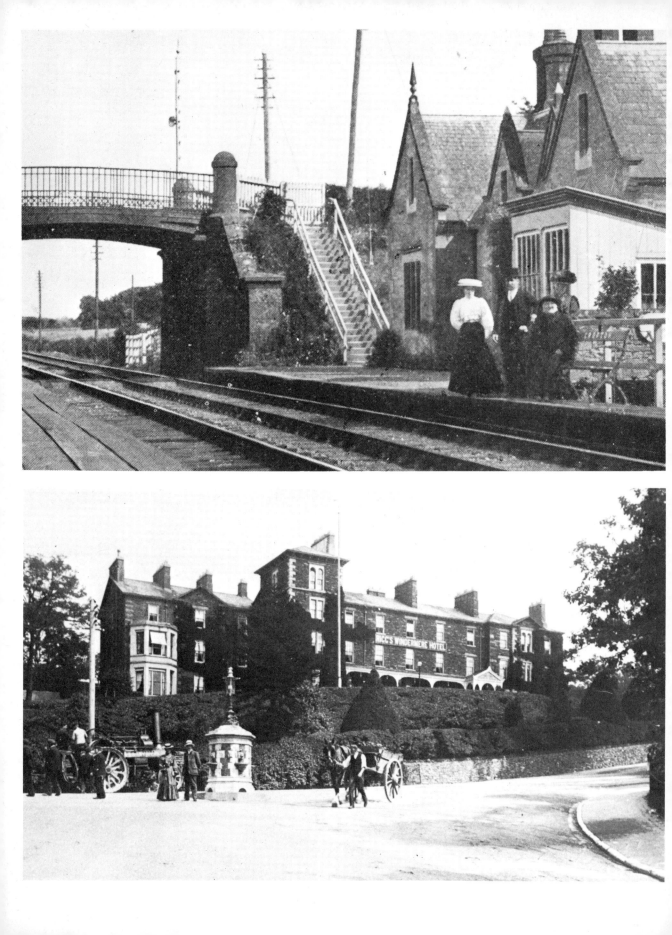

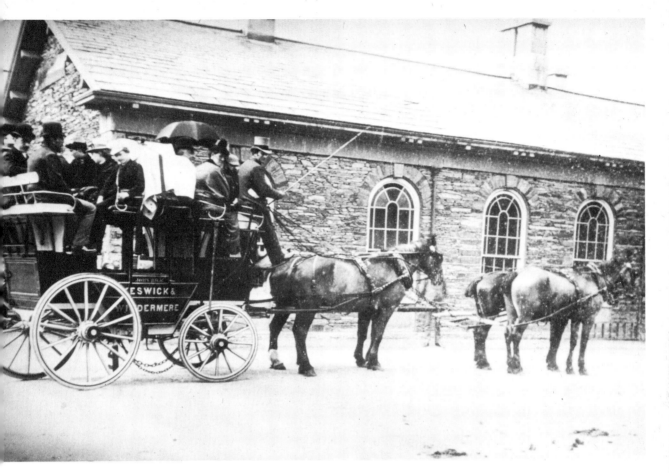

10 *Opposite page top* Another reminder of former social assumptions and claims, which can still be seen (1974) at Crofton near Wigton in Cumberland. The Brisco family of Crofton Hall were directors of the Maryport and Carlisle Railway, seen here, and they used Crofton as their private station. It was one of six such stations in the British Isles in the Victorian age

11 *Opposite page bottom* The visitor in late Edwardian times would have wandered out of Windermere station to encounter this well-known corner. A branch of the Rigg family, noted local hoteliers, ran the Windermere Hotel (1847), and much of Lakeland's tourist traffic passed nearby

12 *Above* The Riggs also provided coaches for the tourists. These waited at the portal of Windermere Station, and carried visitors to all the main areas of interest. The fare from Windermere to Keswick was 7s. in 1884, with payment of up to one third extra for an inside seat! Some passengers perforce had to face the Lakeland weather, and umbrellas were *de rigueur*. Nearby blacksmiths were kept hard at work shoeing the horses, and one blacksmith of this period told the authors that he commonly shoed five horses before breakfast in the summer

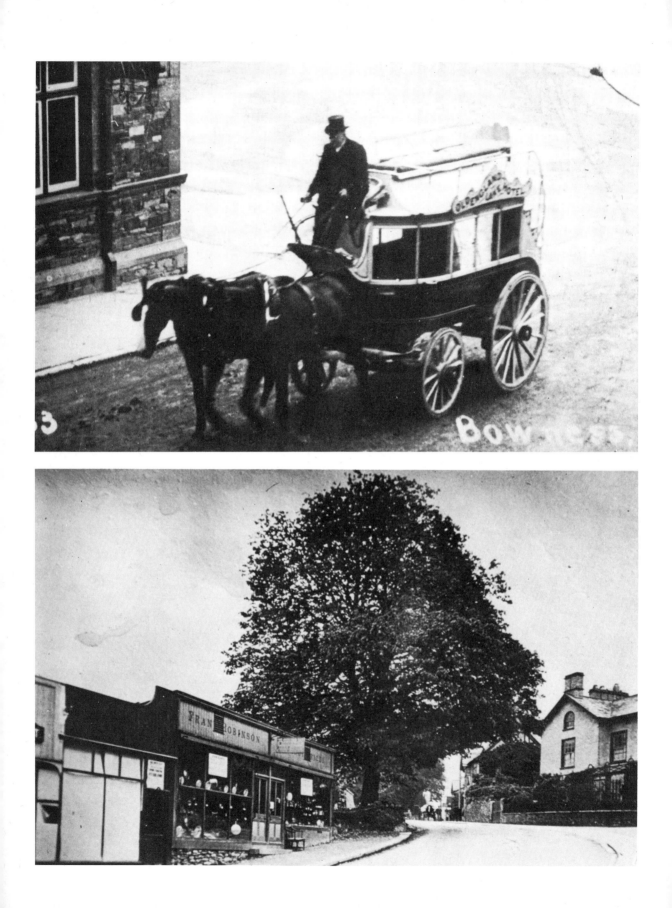

13 *Opposite page top* The noted Old England Hotel, at Bowness-on-Windermere, had its own guest coach, seen here

14 *Opposite page bottom* The traveller wandering about Bowness on foot (in 1906) would no doubt pass Frank Robinson's fent shop ("No Fancy Prices") on Cragg Brow, quite unaware that this business in clothing was run by one of the most remarkable characters (1863–1945) in a region of rich personalities. Robinson's business motto was "Poor but Honest – Nobbut Just", and he once announced that "For the past 43 years I have been diddling the public right and left, and have never been locked up yet. For the next 75 years I intend reversing the process, and hope for the best". A staunch Methodist and respected member of village trade, he commenced business on Cragg Brow in 1887

15 *Above* Mr. Robinson outside his first shop on the Brow in 1888

TOURING THE LAKES

16 Steamer traffic was not restricted to Windermere and this view shows the Furness Railway's famous *Gondola* on Coniston Water, with *Lady of the Lake* on the other side of the jetty. The *Gondola* dates from 1859, and her hulk, at the time of writing, can still be seen at the south end of the lake. This photograph was taken in 1912

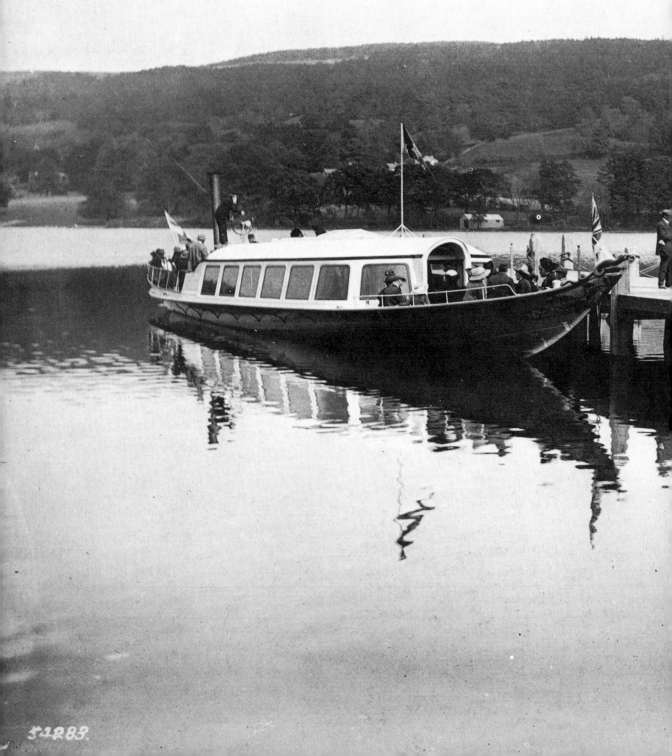

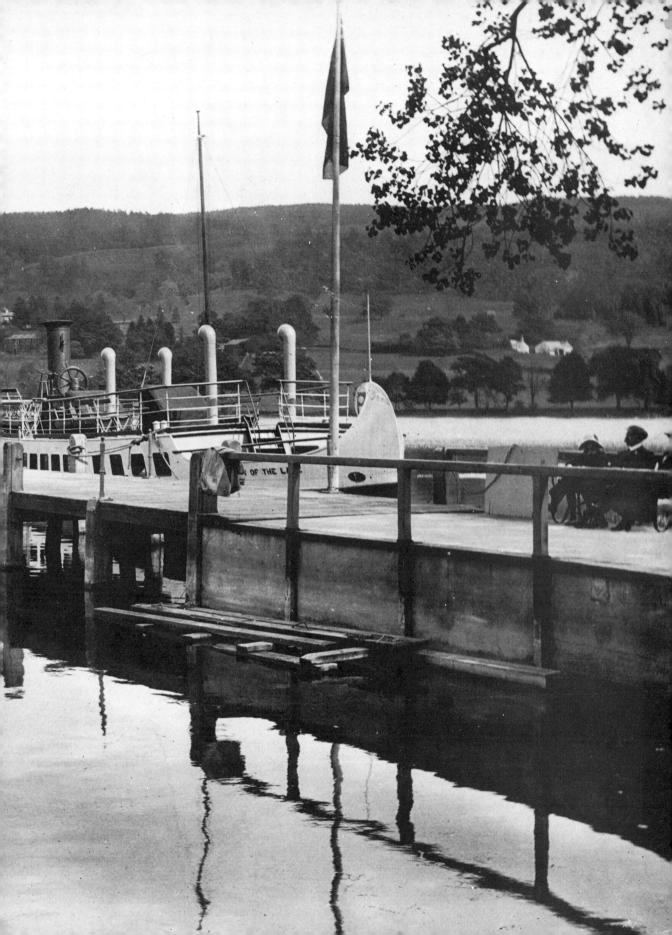

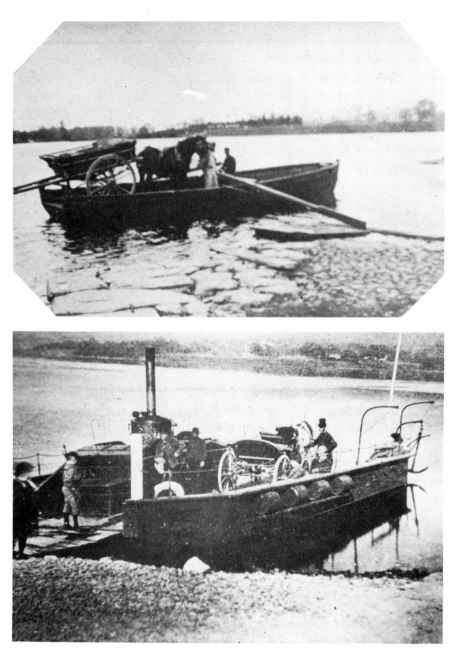

17 Many visitors used the Windermere Ferry on arrival in the district. Until 1860, for example, they would have taken the original man-powered vessel (built 1799), now resting on the lake bottom beyond Belle Isle, and one of a long line of boats used by the Hawkshead and Sawrey people for market and other trips

18 *Left,* **19** *Opposite page top* The ferry service was operated, from about 1860, by a series of steam-powered craft. Here are two views of the middle and late Victorian ferries; the one shown in the side view, with its laden coach, ran from 1869–70 to 1914

20 *Right* The visitors travelling to Lakeside by coach or train – and the rail trip from Ulverston was popular – might well have been excited by this view of the lake steamer *Swift*, launched in 1900 and owned by the Furness Railway. This scene can be partially recaptured even today.

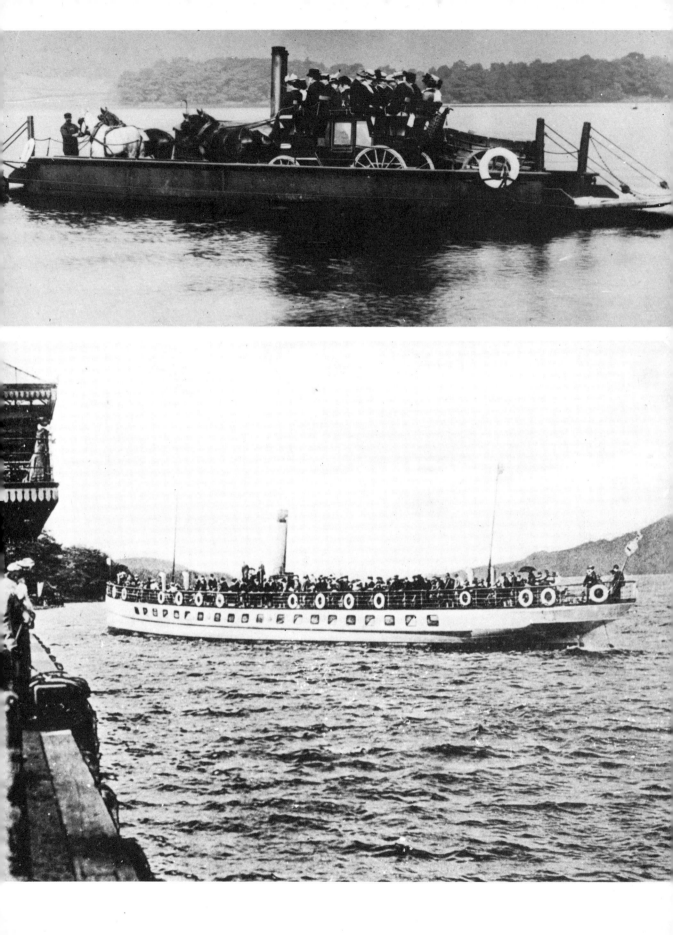

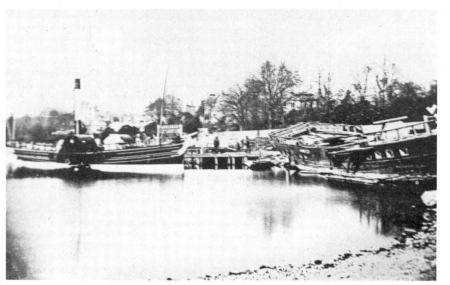

21 *Left* Early steamers on Windermere. *Lady of the Lake,* built in 1845, and subsequently burnt out, is seen on the left, and *Lord of the Isles*, launched 1846, was destroyed by fire as shown here, in 1850. The photograph was taken *c.* 1851

22 *Below* Here is another well-known Victorian lake steamer, the *Tern*, moored at Waterhead, Windermere. *Tern* was launched in 1891

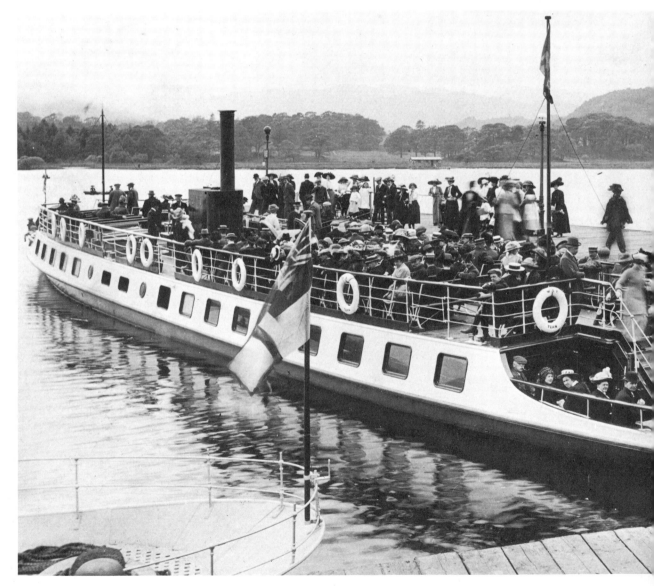

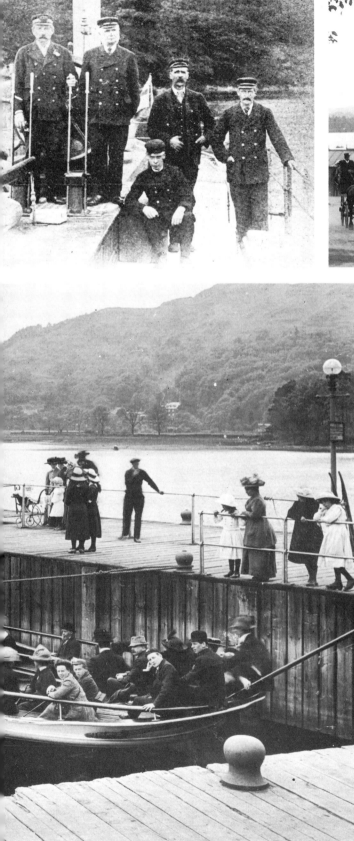

23 *Above left* There were steamers on Ullswater too, and here is the crew of *Lady of the Lake* in about 1895. From left to right are Captain Low, Mr Joseph Smith (steersman), Mr William Hayton (engineer), and Mr Morgan Archdeakin (ticket collector). In front is Mr Joseph Parker of Penrith

24 *Above right* Baddeley's *Guide to the Lake District* of 1844 described the Waterhead scene thus: "Waterhead is a sort of 'Clapham Junction' of Lakeland, the point where the two principal approaches converge, the steamboats landing their freight from Lakeside and the Furness routes, and the rival coaches bowling past from Windermere Station to Keswick". One could find "A mêlée of steamers, row-boats, coaches and conveyances of every sort gathered round the landing stage". This photograph was, of course, taken much later, about 1912, but it still belongs to a vanished age

BOARD AND LODGING

25 *Below* The coach from Windermere station arriving in Ambleside. This corner has changed very little in a lifetime. The Queen's Hotel, a mid-Victorian building, was much less old than the Salutation, although it was strongly recommended

26 *Right* The view of Ambleside along the road past the Salutation Inn corner, looking towards Grasmere and Loughrigg, at the very end of our period; cycling has been long established as a way of seeing Lakeland, and on the left-hand side, in the middle distance, is a motor vehicle

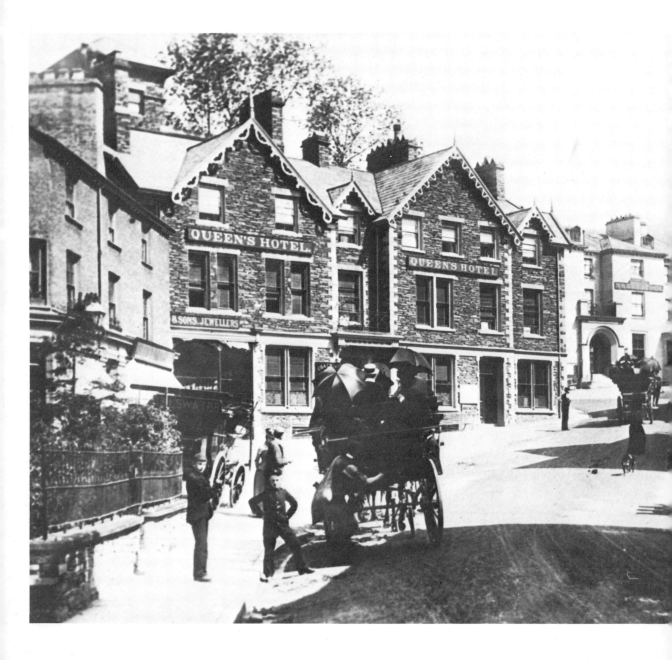

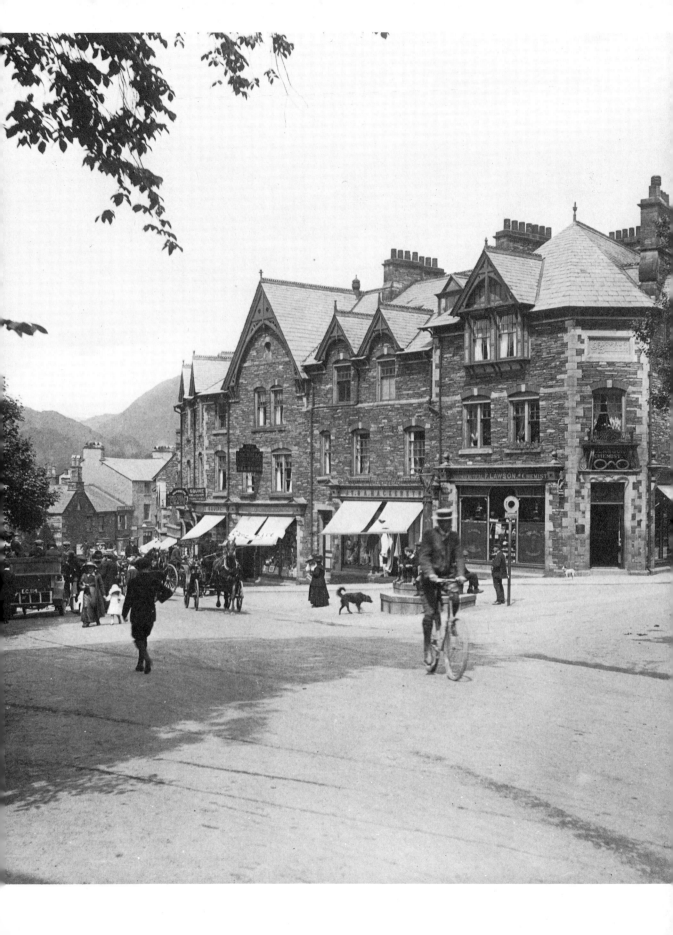

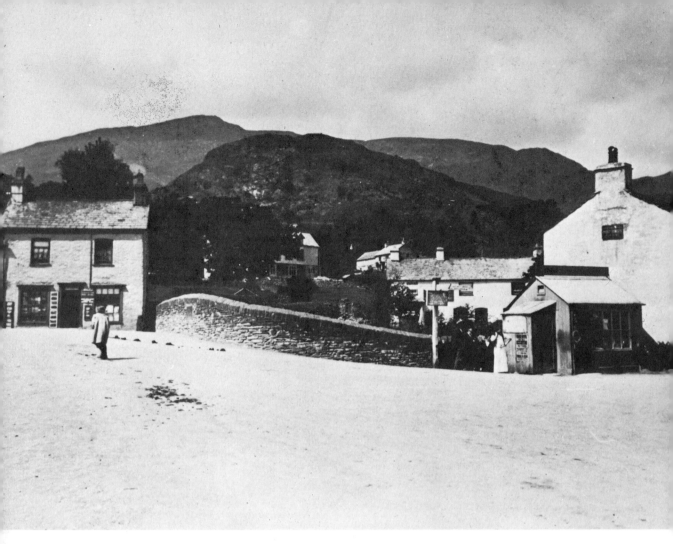

27 *Above* The centre of Coniston about 1905. It had been fairly slow to develop as a holiday centre, although it had been accessible by rail since 1859

28 *Opposite top* The really adventurous visitor might have sought lodgings in Ulpha, beyond Broughton-in-Furness. The occupants of Kirk House are here posing at the front door. Notice the pump at the corner of the house

29 *Opposite bottom* The front parlour of Kirk House – the room between the two front doors shown in the preceding print, and a splendid example of Victorian Lakeland furnishing, with a fine antimacassar on the right, horsehair sofa and lace curtains

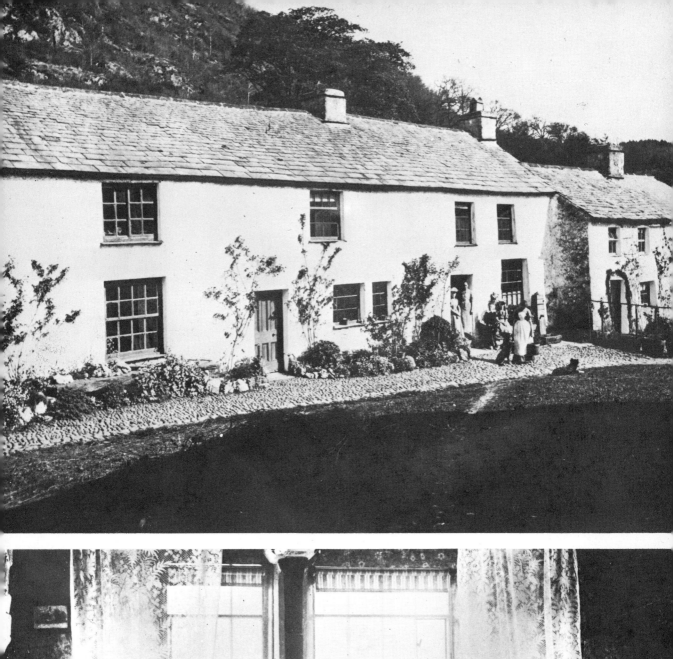
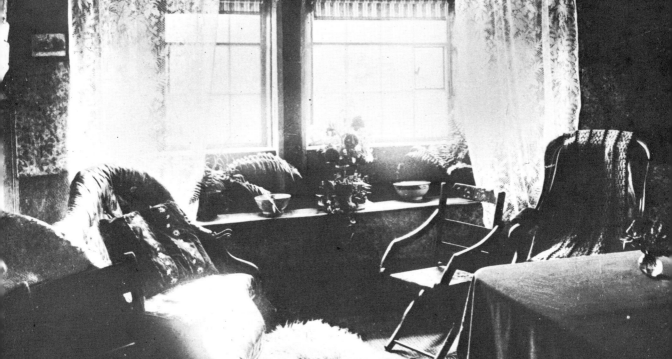

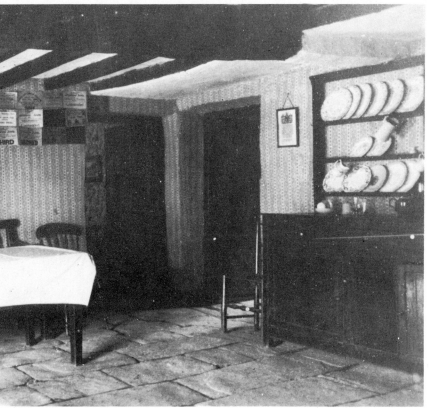

30 *Left* This picture, by Edward Sankey of Barrow, showing an old farm kitchen at Watendlath, about 1910, is a fine example of its kind. On the wall beneath the beams are Keswick Agricultural Show award certificates. Many visitors found good and simple fare in farms like this

31 *Below* The kitchen at Hampsfield Hall near Grange-over-Sands was richly redolent of an agricultural past, with its horse furniture and fire-irons and its patent manure advertisement

32 *Right* In contrast, we here see Lakeland catering at its most resplendent; the table laid for luncheon in the large drawing room of the Old England Hotel on the occasion of the Kaiser's visit in 1895. The bill of fare included three choices of fish and 16 of meat or poultry

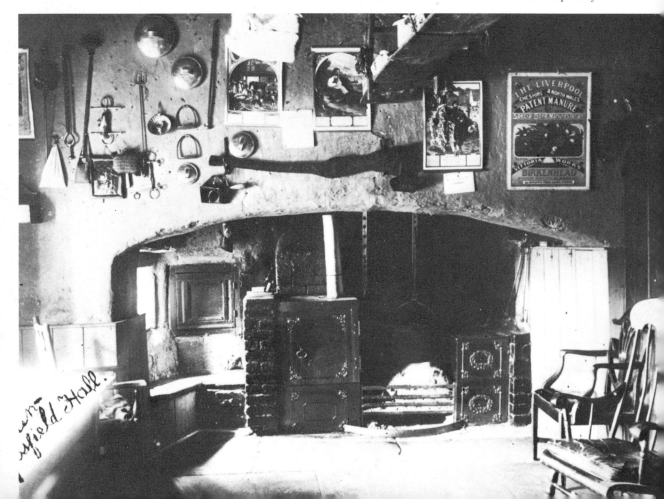

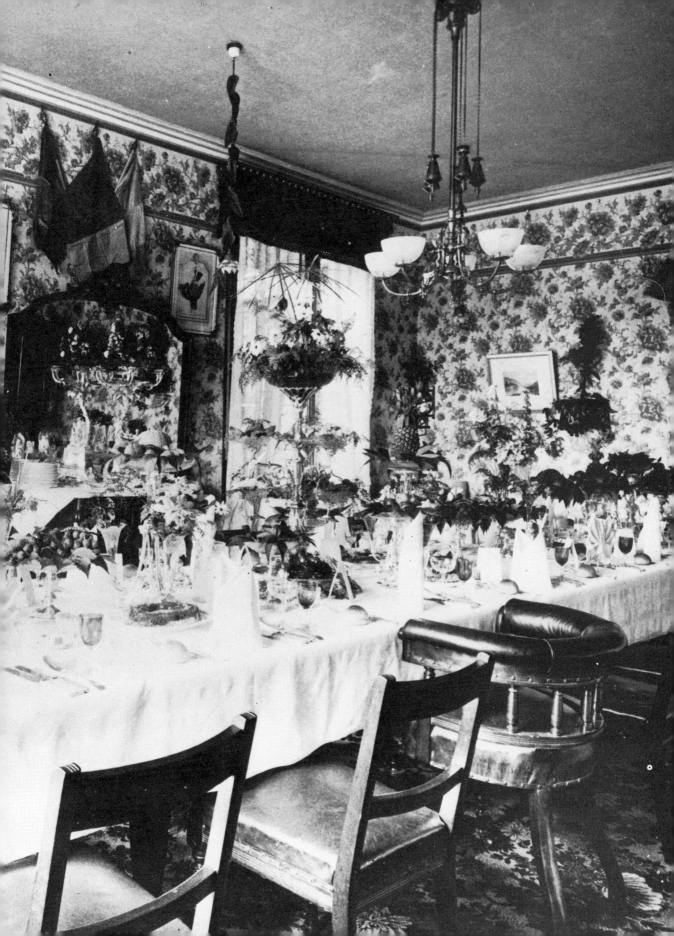

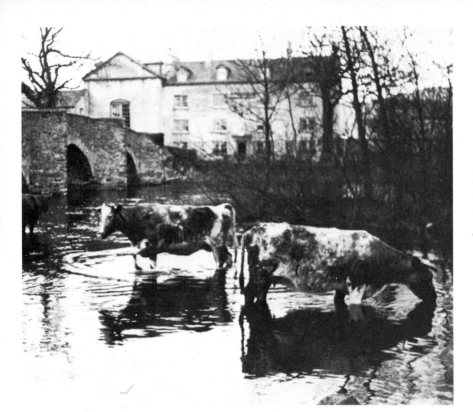

33 *Left* The Swan Hotel at Newby Bridge had an even more rural atmosphere a lifetime ago

34 *Below* Increasing numbers of visitors were being catered for in the boarding houses of the Lakeland towns. Here are the proprietors and guests at a house in West View, the Heads, Keswick, posing in about 1911. The fiancée of the photographer, W. C. Lawrie, is on the right

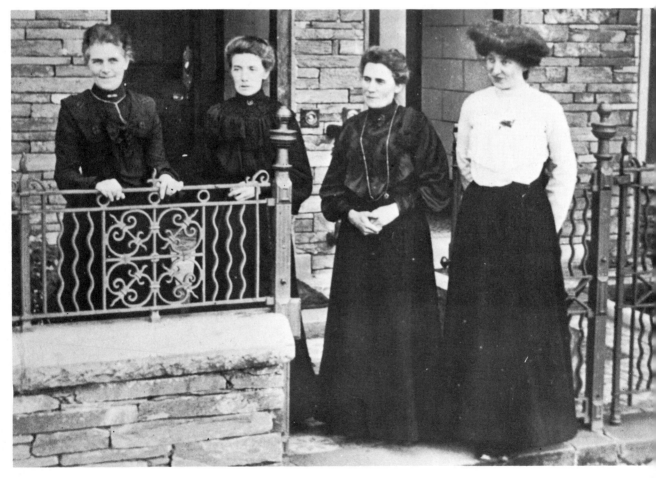

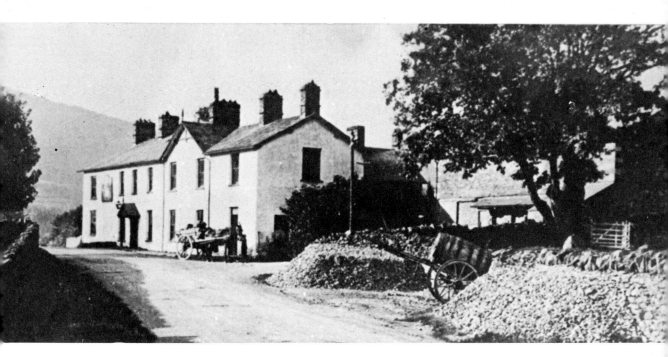

35 This section of the Ambleside–Keswick road, showing the famous Swan Hotel at Grasmere, has changed markedly. The hotel, one of the oldest-established in the area, has altered little in the last 80 years

36 The Crown Hotel, Grange-over-Sands, shown here in its guise of 70 years ago, was in fact there before the town grew up. In 1829, the Crown Inn (as it was then known) was kept by Thomas Lamb, victualler

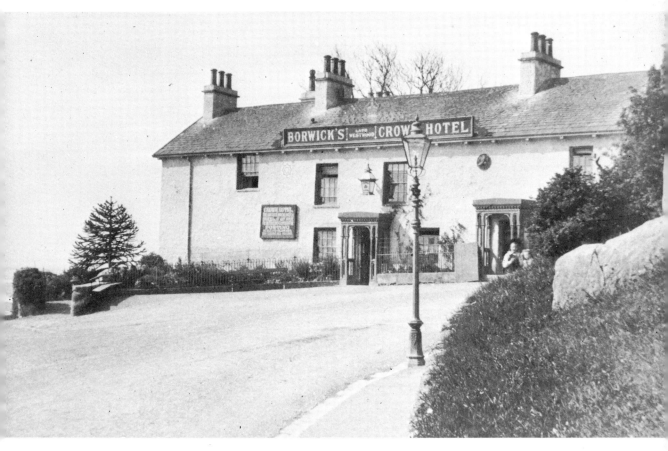

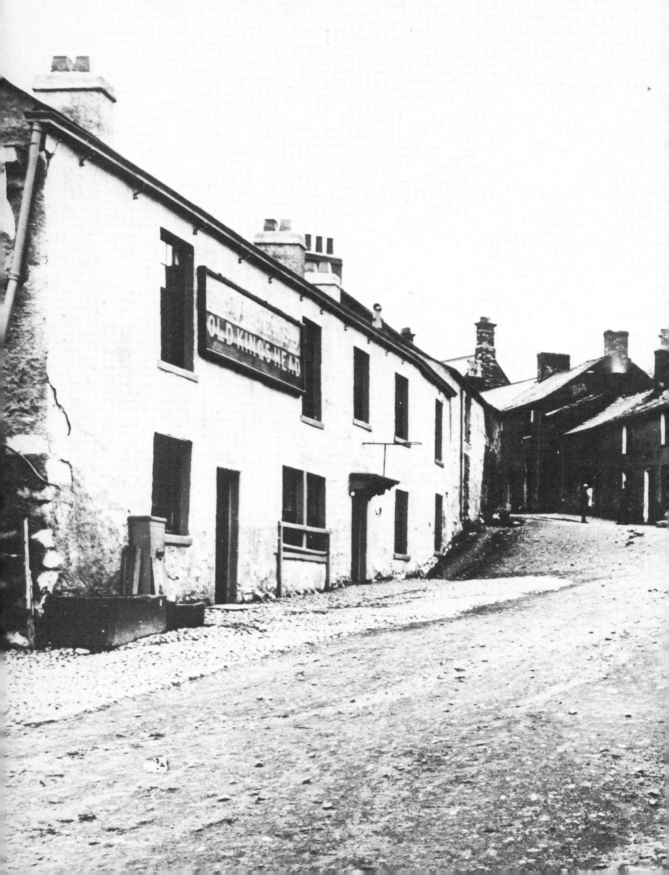

37 The Old King's Head, Broughton-in-Furness, was a hostelry visited in the 1860's by Edwin Waugh. Here is the view as it could have appeared to that lively author

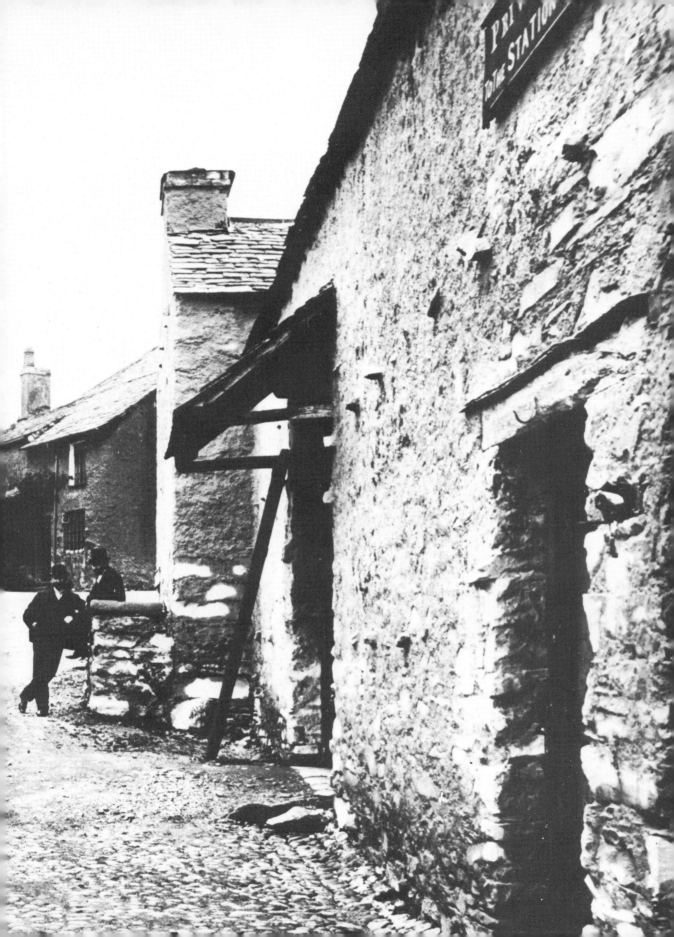

OUT AND ABOUT

38 *Below* In the days before regular buses and the frequent motor car, to walk in Lakeland lanes could be itself an exhilarating experience. Here is the photographer Sam Thompson of Lancaster setting out along the Kirkstone road, near Troutbeck, in Easter 1913. He is looking straight at Pet's Quarry

39 *Right* Climbing became well established in this age, even though the adventurous pioneers might be seen wearing Norfolk jackets and knickerbockers – and soft hats. This picture is from the fine Abraham collection

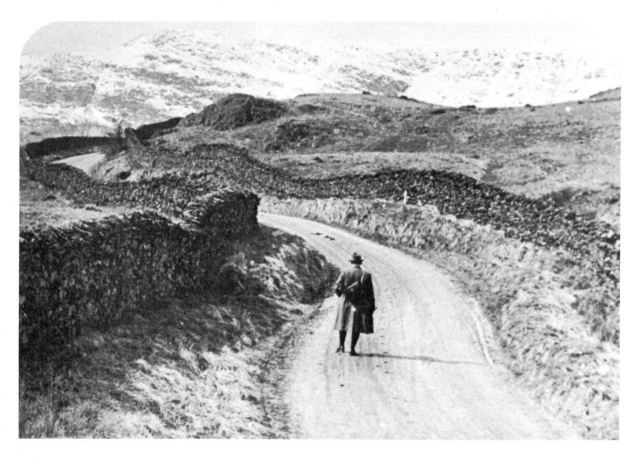

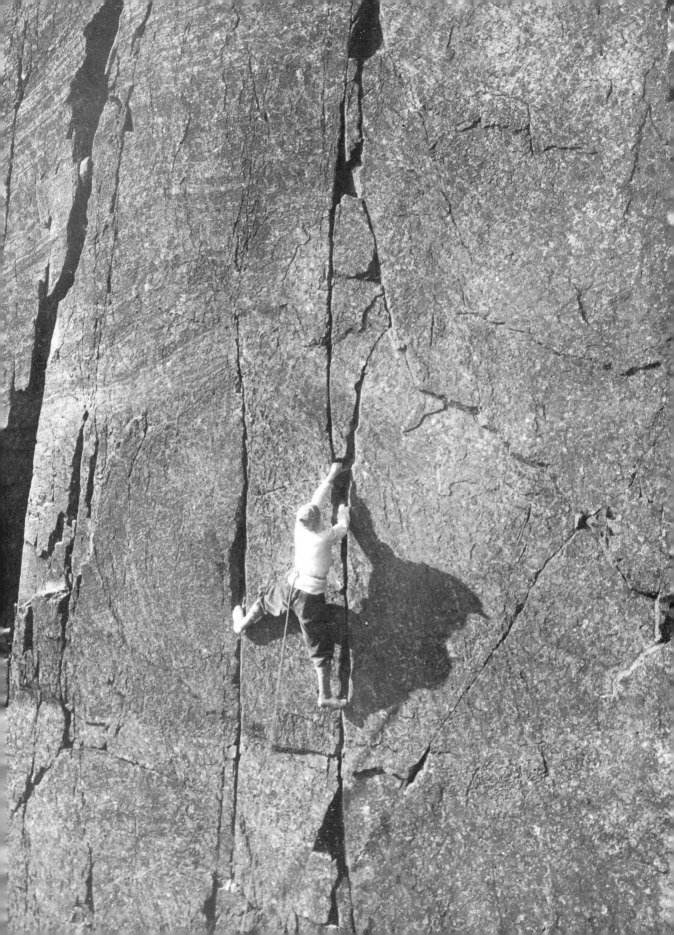

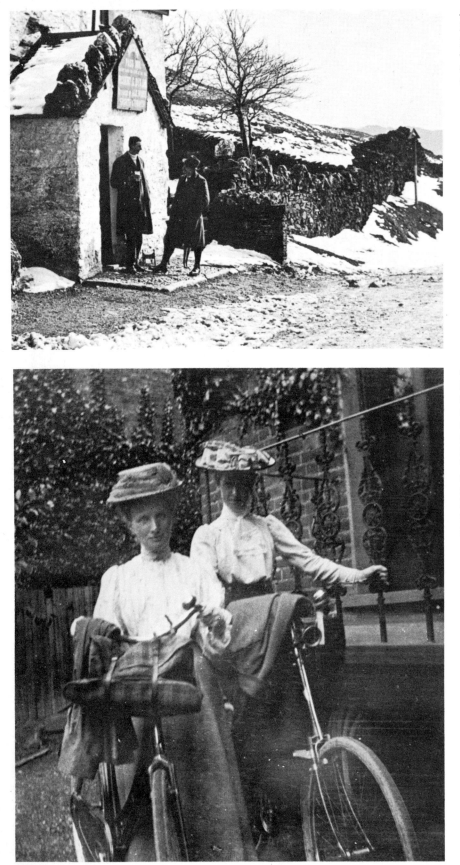

40 Mr Thompson is shown here at the Kirkstone Inn, a port of call. Despite the snow, one could enjoy a glass of ale at the door on that superbly caught Easter Monday

41 Baddeley's famous *Guide to Lakeland* began to include a section for cyclists before the end of Victoria's reign, and these two intrepid ladies (photographed by W. C. Lawrie) had no doubt read his warning: ''where accidents have occurred, they have often resulted from the rider not having learnt the difference between a stone wall and a hawthorn hedge''

42 On the slopes of Honister where, as Baddeley remarked, ''Rigg's four-horse coaches have a country-wide reputation''

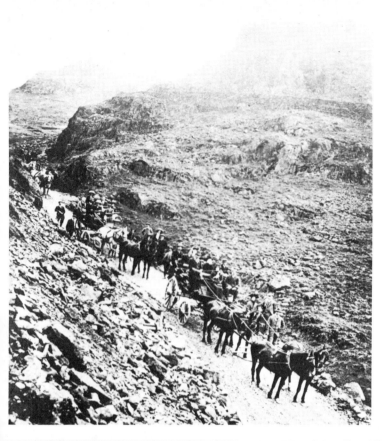

43 The coaches – which could be dangerous to passers-by – served also to take parties to church (1898). Here is such a party at Wythburn church, then fairly recently enlarged by the addition of a chancel higher than the nave

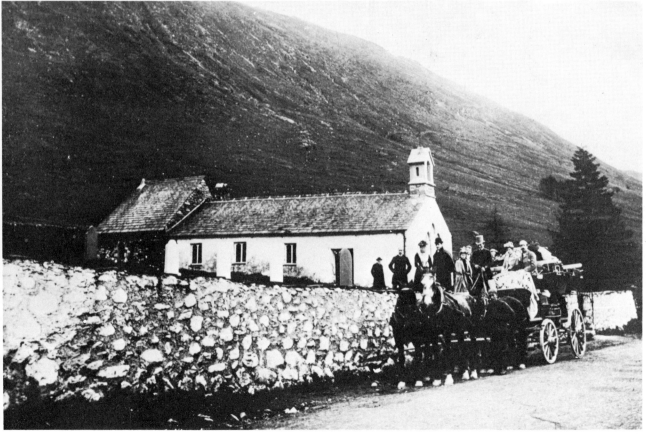

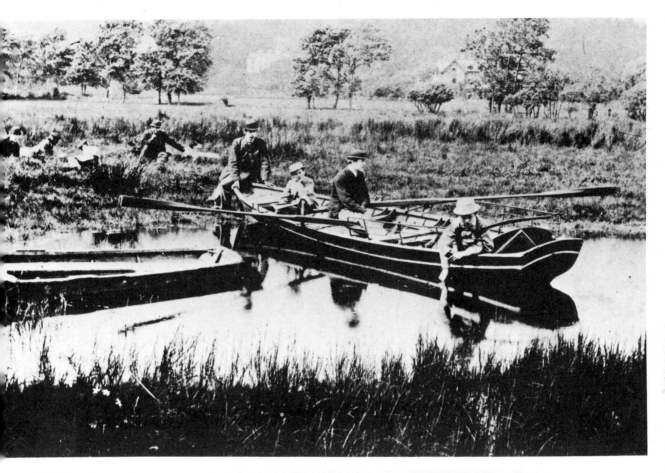

44 *Opposite page top* Everywhere were peaceful, dusty roads and lanes, like the Bassenthwaite road near Mirehouse. This photographer was lucky enough to meet the Blencathra foxhunting pack

45 *Opposite page bottom* Many Victorian and Edwardian families just wandered, like this group at Tranearth above Torver (Coniston)

46 *Above* This photograph is one of the earliest in our collection; a boating party near Coniston in the 1850s, taken by Yewdale Beck

47 *Right* A sign of emancipation – ladies playing golf near Cockermouth

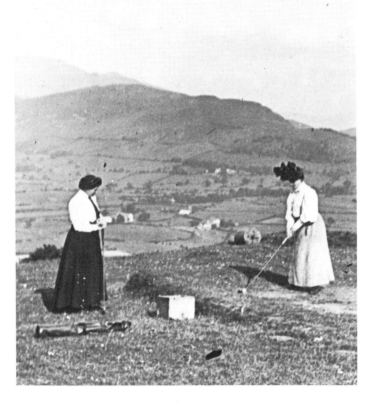

48 A poignant view of a
Lakeland spring – in the spring-
time of our grandparents;
Ulpha, looking up Dunnerdale

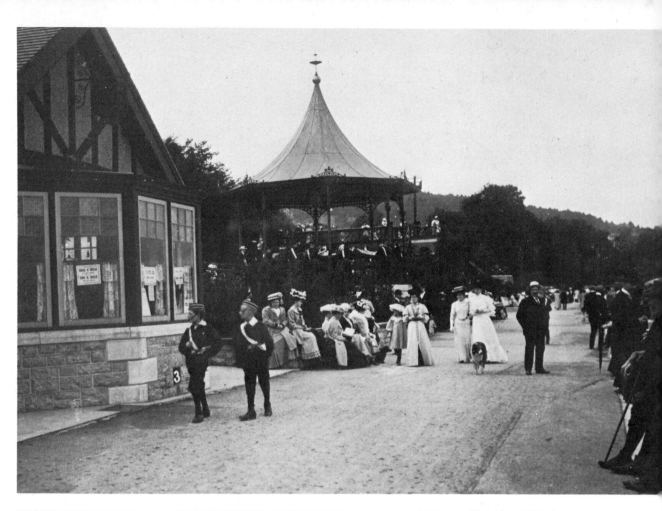

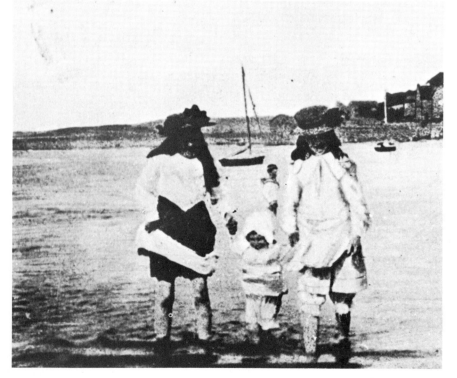

49 *Above* This decorous scene shows the bandstand, pre-1914, below Berners Close at Grange

50 *Left* A decidedly Victorian view of Arnside

51 *Right* Another picture from the Abraham collection

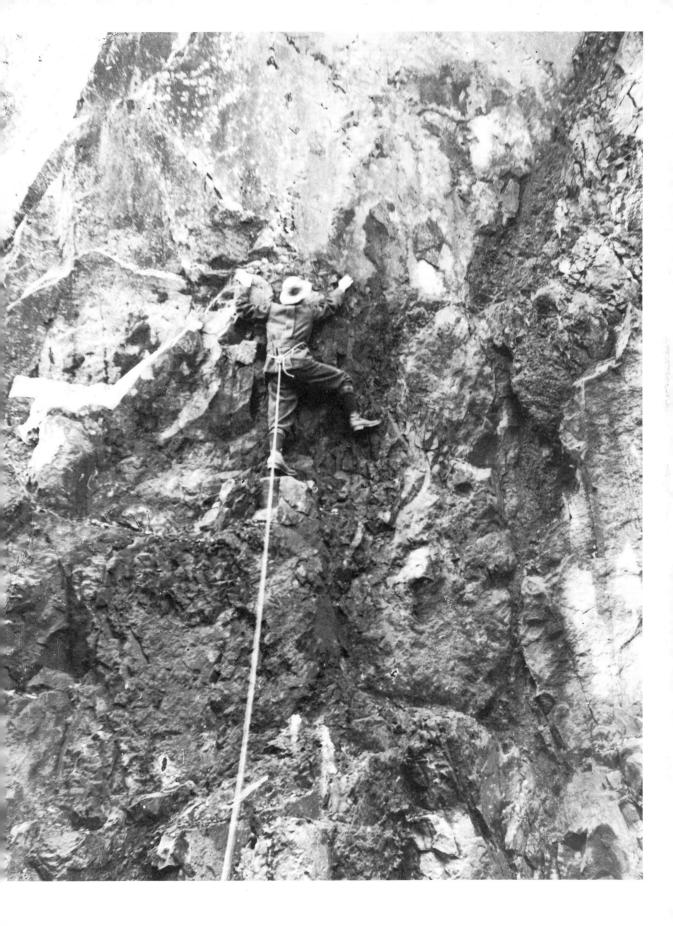

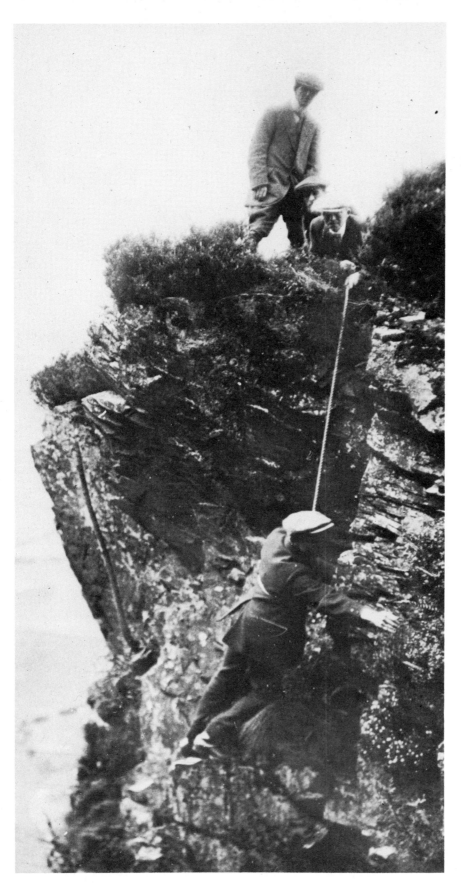

52 *Left* The photographers were sometimes themselves climbers. W. C. Lawrie, with friends on the higher level, is here seen moving into position at Melbreak. He was one of the finest bird photographers of his time.

53 *Right* Sam Thompson photographing Red Screes

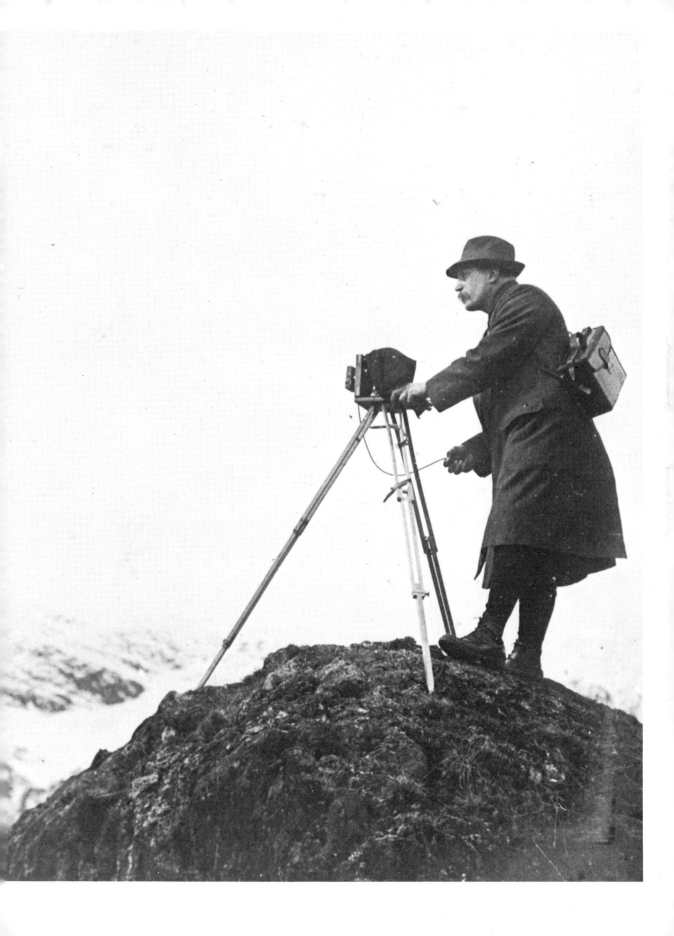

SPECIAL OCCASIONS

54 *Below* Grasmere Sports. This great annual event, carried on in torrid or torrential August weather, is a socially-graced survivor of the dozens of local sports, games and regattas which were to be found everywhere in Lakeland – at, for example, Flan (Ulverston), Windermere Ferry, Pooley Bridge, Talkin Tarn and Keswick. Wrestling and hound-trailing or regattas were combined at all of these places in the early years of Victoria's reign, when the railways brought great audiences together.

The Grasmere Sports received the especial patronage of the regional aristocracy and gentry, as this view suggests, and here one might easily see the Earl and Countess of Lonsdale, Lord Henry Bentinck, Lord Muncaster, Lord Hothfield, the Earl of Bradford, and Viscount Cross, as well as dozens of wealthy "offcomer" settlers and visitors like Sir William Forwood, presiding genius of the Windermere Yacht Club. The real committee work was done by long-established local gentry, members of the Machell and Pedder families included among them

55 *Right* The wrestlers made the real entertainment at Grasmere, like George Steadman of Whitehaven and George Lowden of Workington, both of whom appear on this picture. Steadman was champion of this Westmorland ring for about 30 years (he is seen standing apart in costume on the right), and retired from the contests in August, 1900. The first prize in this fiercely contested competition was £15 and a champion's belt

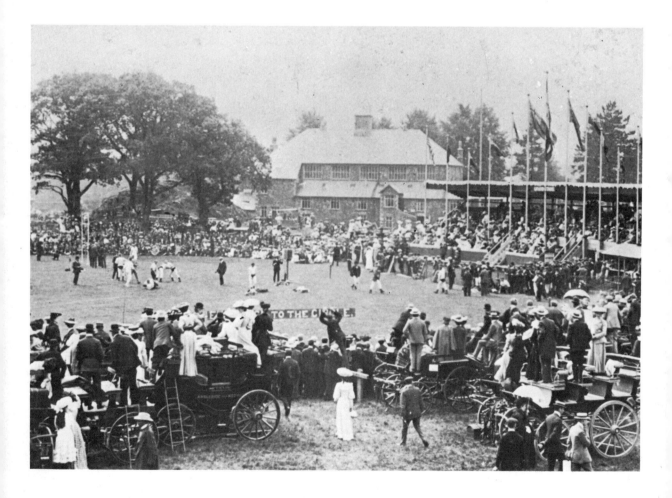

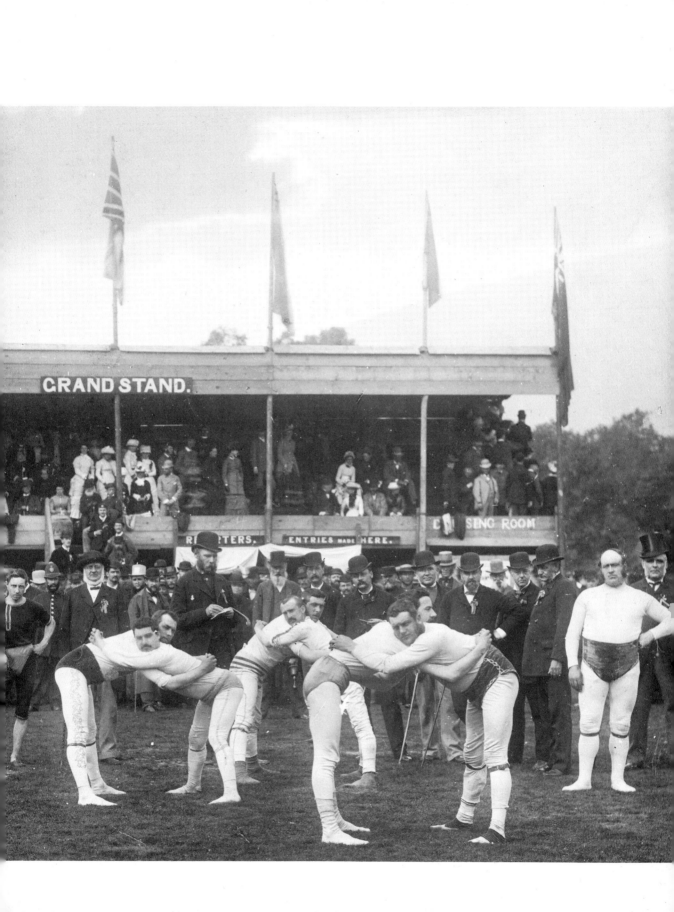

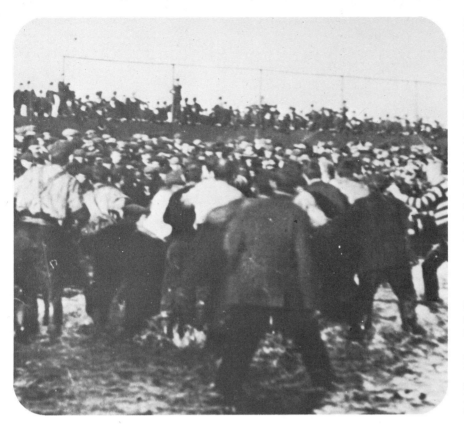

56 *Left* Mass football matches between Lakeland villages were by no means unknown, a custom which also survived in the industrial towns. This view shows the townsmen of Workington engaged in the annual battle between the "Uppers" and the "Downers". The "pitch" stretched between the harbour and Workington Hall grounds, and on one famous occasion a local lady caused consternation by hiding the ball in her child's pram! This wet and muddy event took place during the Easter period

57 *Below* Industrial skills were sometimes put to the test, and at Braithwaite Sports in about 1900 these lead miners, probably from the nearby Thornthwaite mines, are hard at work competing with hammer and "jumper" or steel chisel, in a rock-boring contest

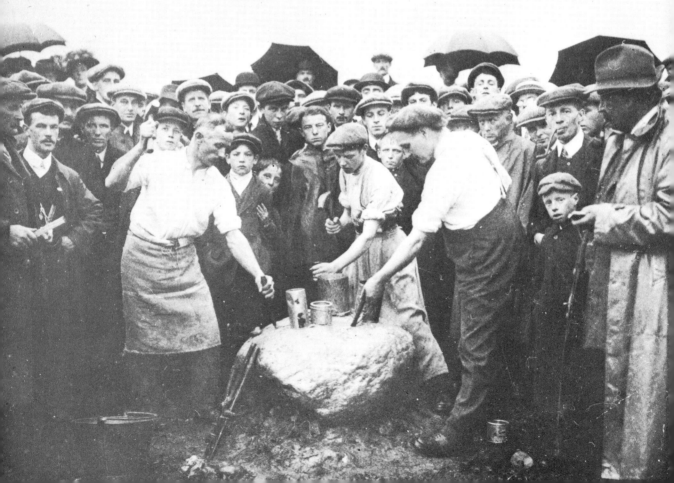

58 *Right* Here is the result of another kind of skill, that of stone-throwing – the shattered windows of the Newfield Hotel, Seathwaite, following a riot by local navvies on 25 July 1904

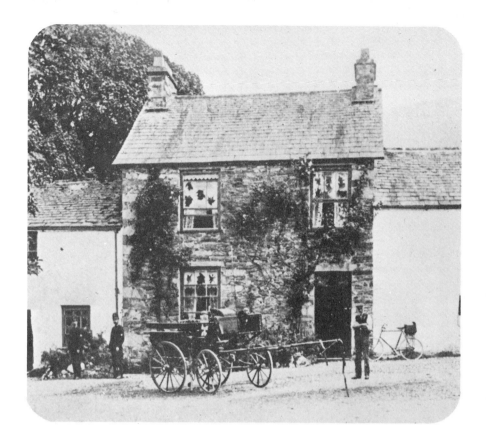

59 *Below* The French aeronaut M. Maurice Ducrocq going through his paces at Workington, with the help of local lads. The landing strip was at the Mill Field, and the photograph was by the ever-enterprising W. C. Lawrie

60 In 1860 the Windermere Sailing Club was established, and in 1884 the members rented a clubroom in the Old England Hotel. The Club received a Royal Warrant in 1887

Vessels built to the first-class specification laid down by the Club were 22 feet along the waterline and carried some 700 square feet of sail. Morecambe Bay shrimp fishermen were originally used at the helm, but their use was eventually restricted to that of crewmen only. The Club's regattas attracted much attention, and brought in many wealthy visitors

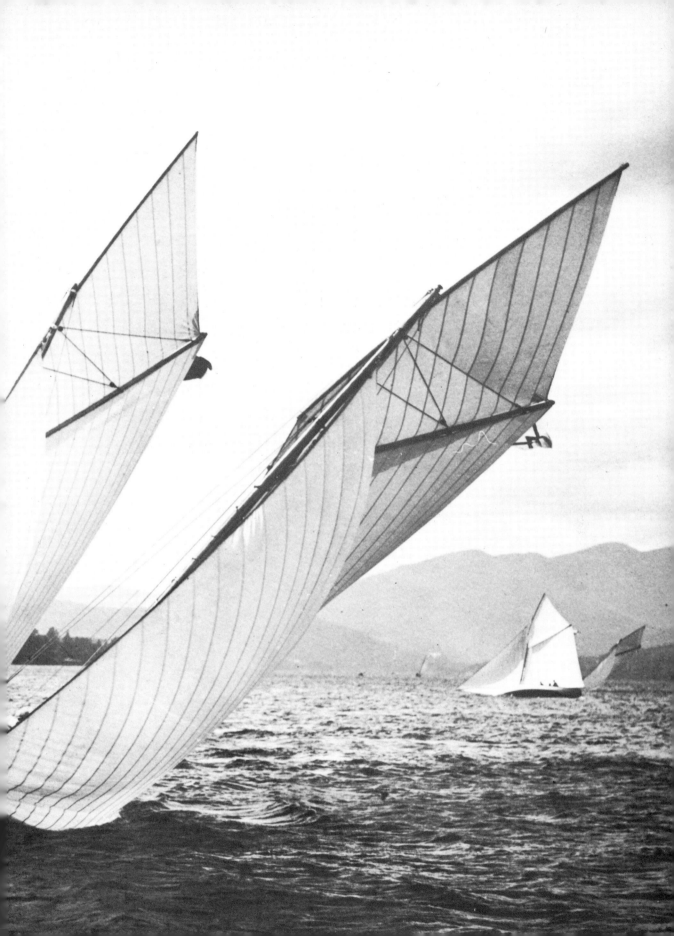

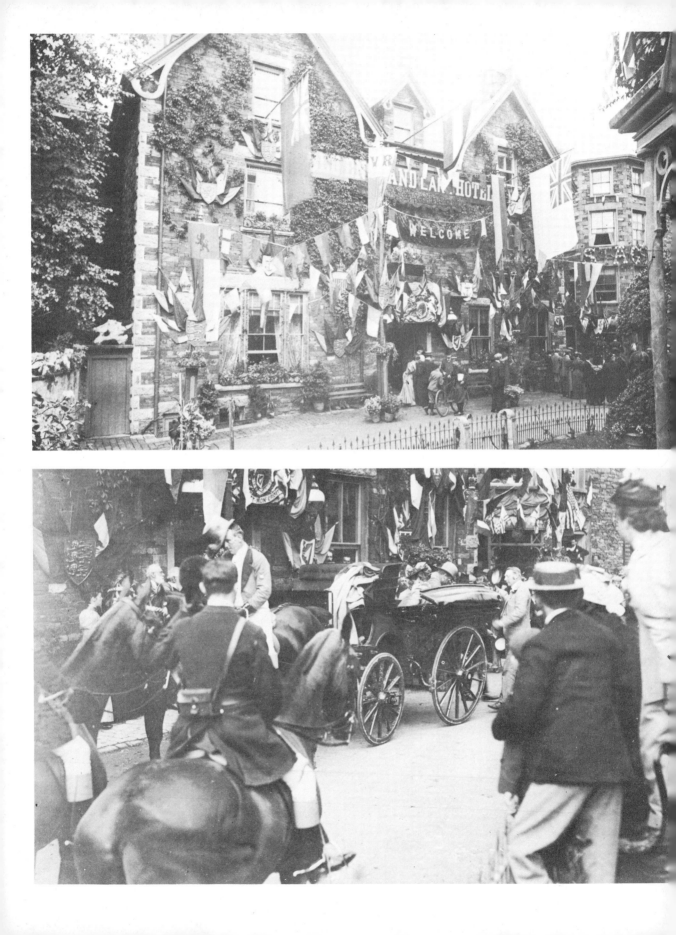

61 *Left* The Old England Hotel at Bowness-on-Windermere, associated with the yachtsmen, is shown here dressed up for a very special occasion indeed – a visit of Kaiser Wilhelm of Germany to the Lake District. His arrival at the Hotel was to take place soon after 2.30 p.m. on 11 August 1895, and this picture shows a few knots of expectant watchers, soon to give way to an excited throng. The Kaiser had taken breakfast at Lowther, and all the villages and towns in his path, including Ambleside, were decorated in his honour and in that of his hosts, the Earl and Countess of Lonsdale

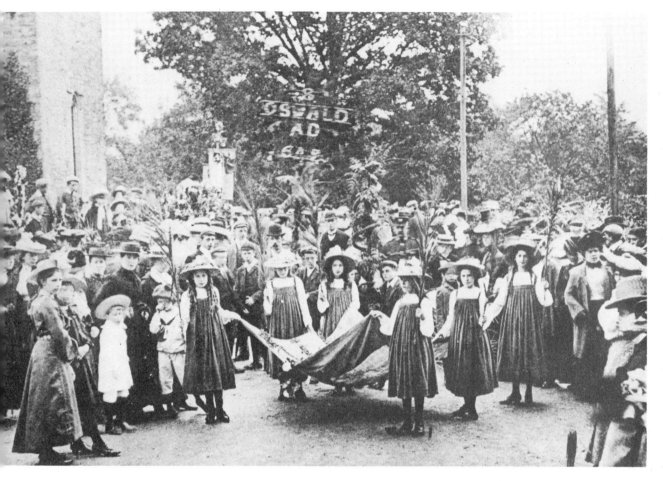

62 *Left* The Kaiser's retinue was preceded by huntsmen in scarlet jackets, followed by yellow-bodied carriages (of the familiar Lonsdale kind), each drawn by a pair of chestnut horses with postilions. At this instant of time, Lord Lonsdale, seen on the right of the carriage, has descended, and is being followed by the Kaiser, who is about to hand out the ladies in the carriage. The Old England Hotel entrance was covered with crimson cloth "with grey beneath" – a premonition of the all too familiar field grey of the future?

63 Rushbearing is not of course confined to Grasmere (seen here) or Ambleside; there is a deep-rooted traditional ceremony at Warcop in Westmorland, wherein the boys of the village carry crosses made of rushes, and the girls great crowns hemmed with flowers.

64 Queen Victoria's Diamond Jubilee inspired some ingenious and massive street decorations. Here is the decorated arch on English Street, Carlisle. These old street photographs (see our later section on Towns and Villages) are of especial fascination because one can take them into a relatively safe and dry corner for a few minutes, and compare the changes in the frontages that have taken place

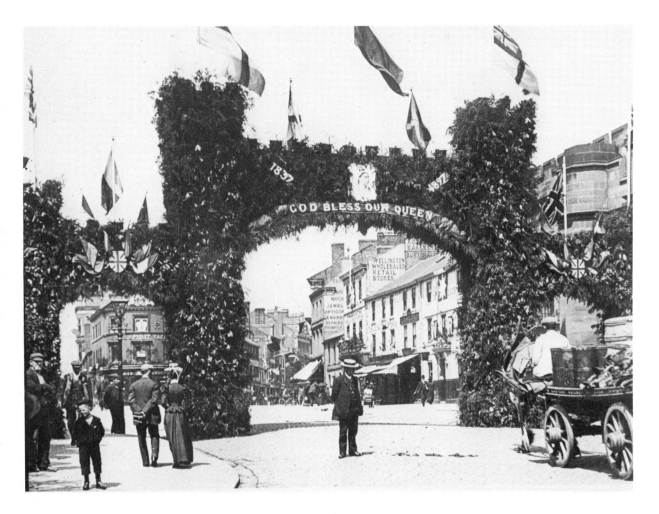

65 One can hardly survey
Edwardian Lakeland without,
at some point, encountering the
dedicated figure of Canon H. D.
Rawnsley, who caused this
photograph – of Whitehaven's
coronation bonfire of 22 June
1911 – to be made because he
was a passionate if romantic
advocate of bonfires and
beacons. He kept a published
record of commemoration fires
throughout Lakeland and
England. This Whitehaven
erection certainly deserves to go
down to posterity, although
some beacons were built in
much more inaccessible places,
like the top of Skiddaw, and
the whole of the region was
illuminated on that occasion

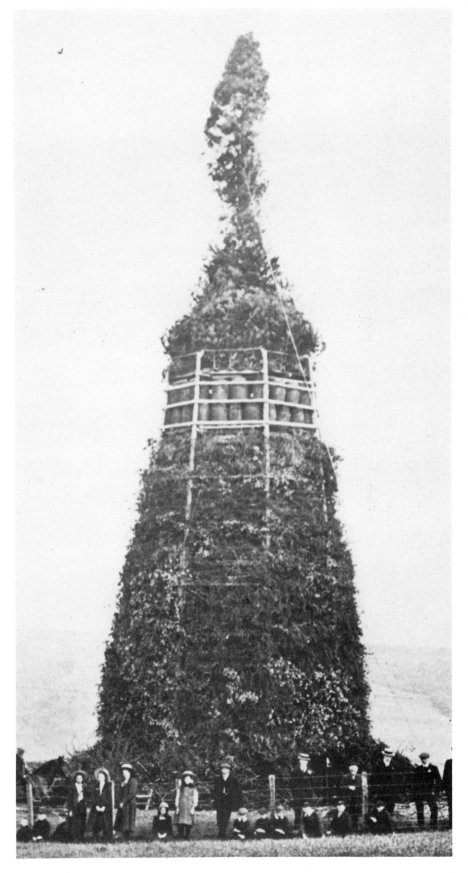

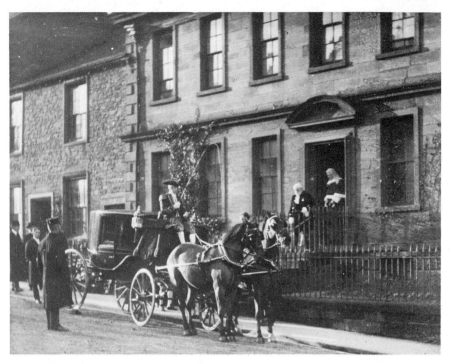

66 *Left* John William Fothergill, High Sheriff of Westmorland, leaves the Judge's Lodgings for the Appleby Assizes of 1911, with the Judge following him

67 *Below* A characteristically fine posed photograph, by the late W. C. Lawrie of Workington, of a May Queen Festival in Keswick, in which nearby villagers participated

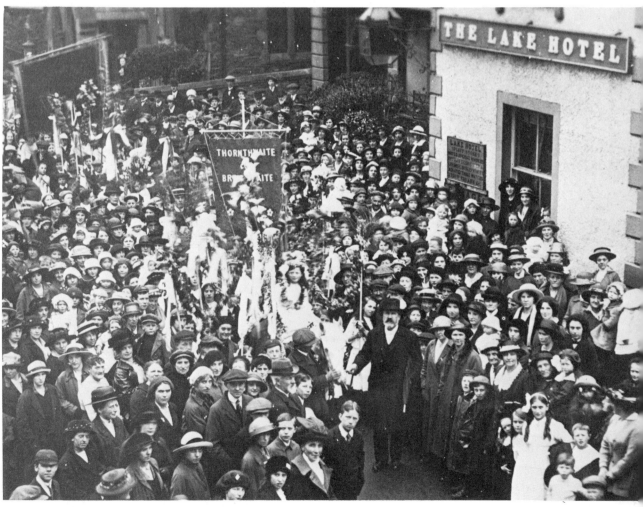

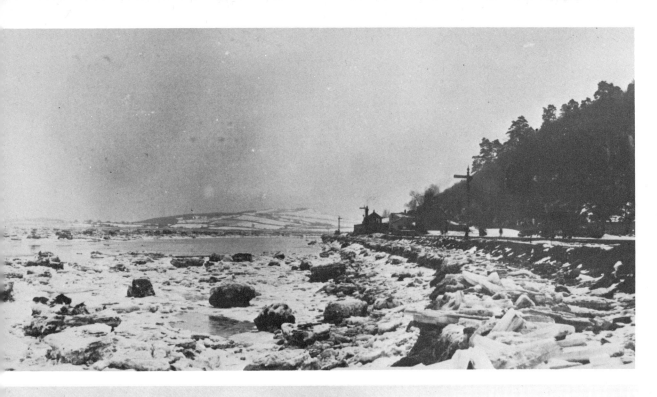

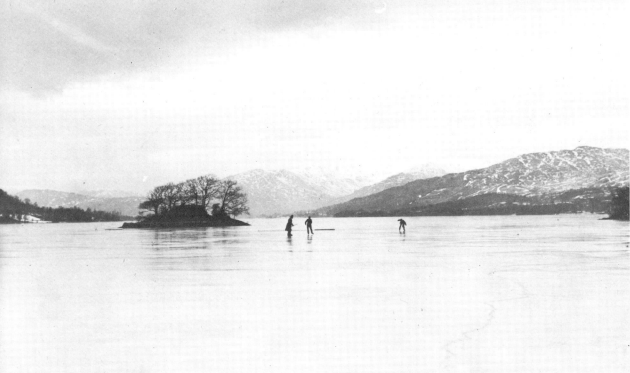

68 *Top* Nature played its part in "Special Occasions". The year of 1895 brought not only the Kaiser to Lakeland, but also a Great Freeze which has gone down in history. In the February, the sea froze, and here is a view of the side of the Leven Estuary at Greenodd

69 *Above* This superb photograph by Brunskill of Windermere, one of the district's finest photographers, looking northward up Windermere which froze over in February 1895

70 Windermere in February 1895, and covered with skaters. This is a photograph by Brunskill. Notice the late Victorian perambulator in the foreground.

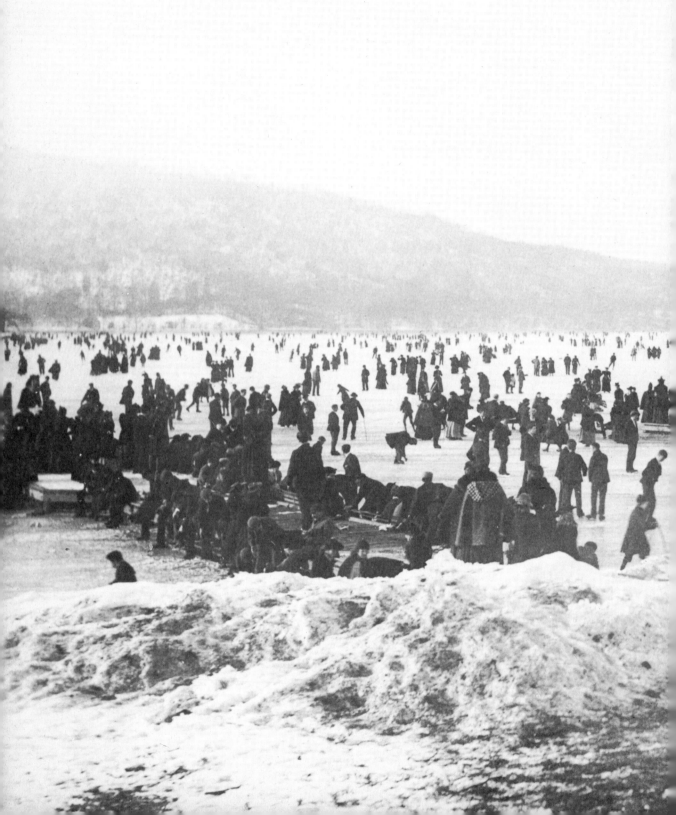

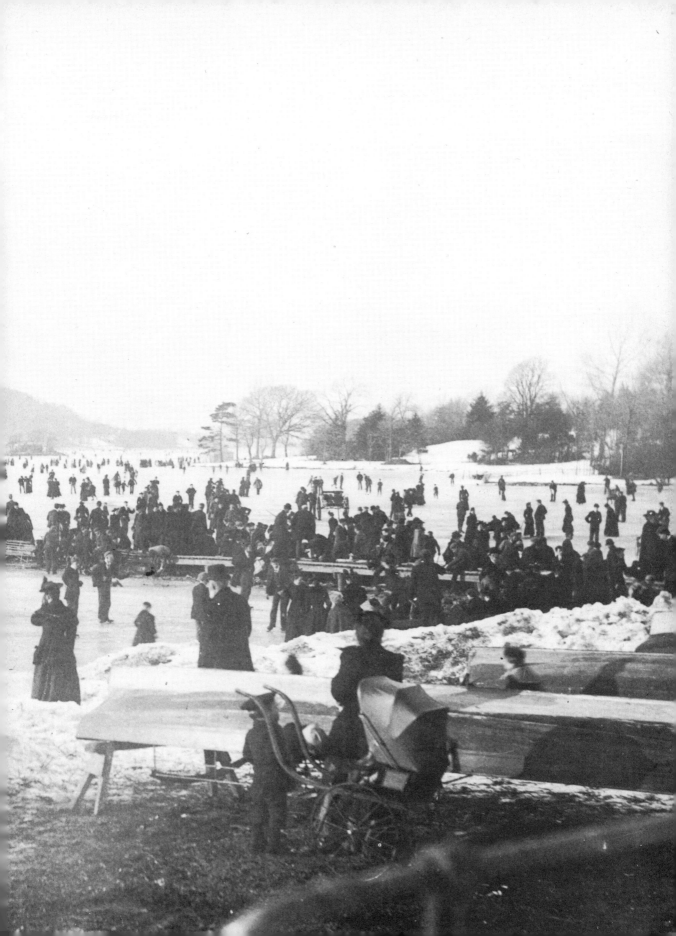

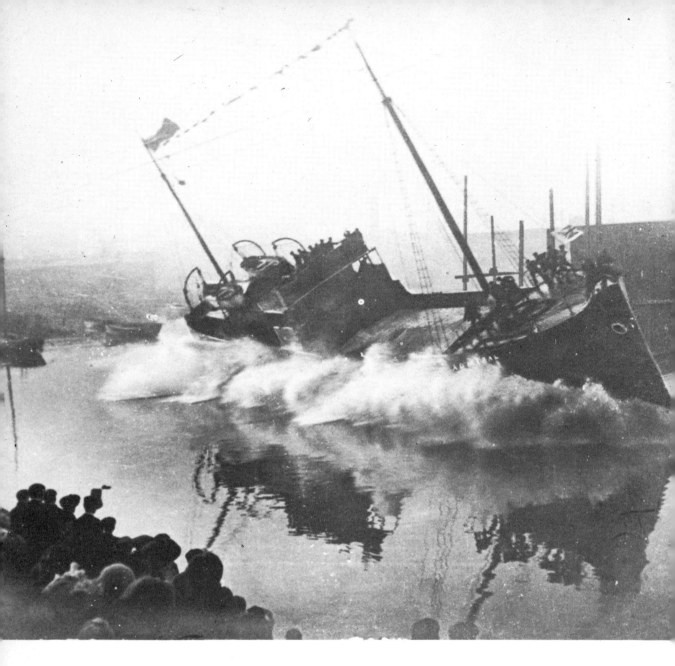

71 *Above* Shipbuilding was carried on in several Cumbrian ports, and in all of these a ship's launch was a very special occasion. There were several shipyards on the River Ellen at Maryport, and the one in the picture is the former Ritson's yard (later, Walker's). The ships were, as shown here, launched broadside into the 30-foot river, and they rolled in with a magnificent tidal wave which drenched the spectators on Mote Hill, just over the other side. The vessel shown is the S.S. *Admiral*, launched on 29 November 1905 and built by William Walker. The photograph is by Baxter of Maryport, probably Robert Baxter, the former musical instrument dealer of Curzon Street

72 *Opposite page top* Colour and spectacle were not entirely absent from the industrial towns, and Barrow's pageant plays have a long history. Here is the Cavendish Park pageant of 11 September 1909, in aid of the town's North Lonsdale Hospital. This is an example of the outstanding camera-work of Edward Sankey

73 *Opposite page bottom* Only a few days later (18 September 1909), an altogether more cataclysmic event occurred at Distington on the West Cumberland coast, when an ironworks boiler was hurled clean over the railway line by the force of its explosion. The camera of W. C. Lawrie caught these Edwardian children standing on the whale-like monster

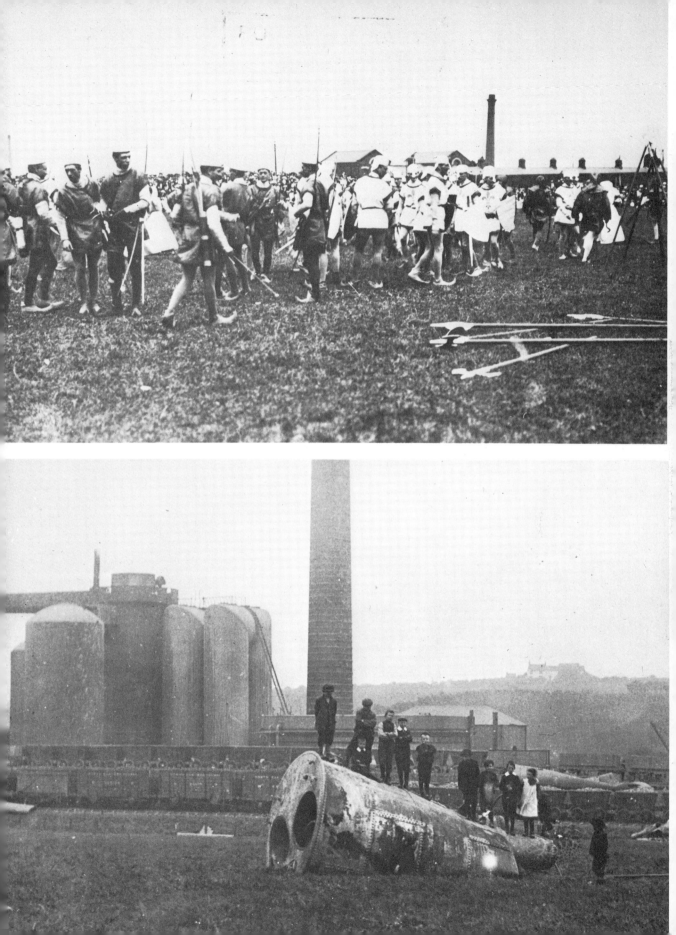

PEOPLE

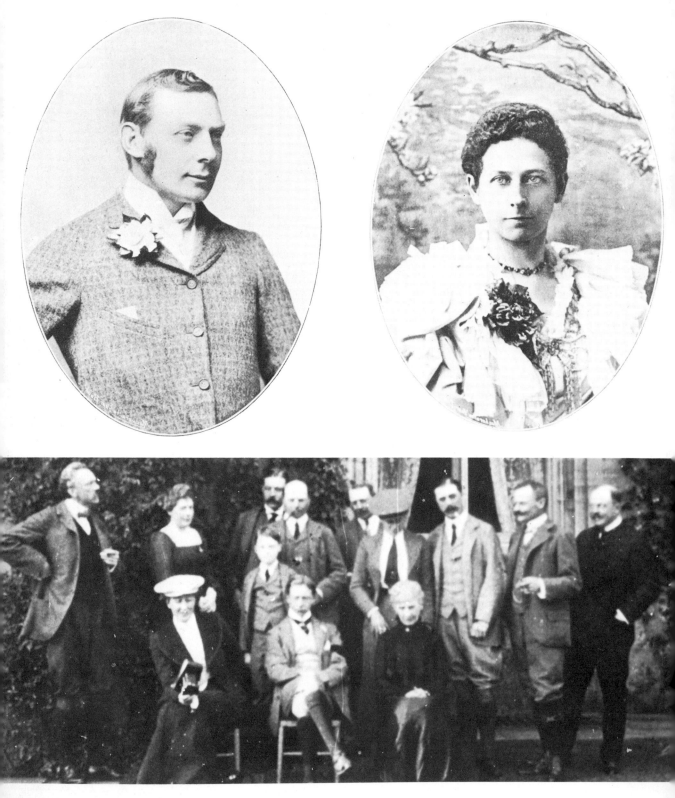

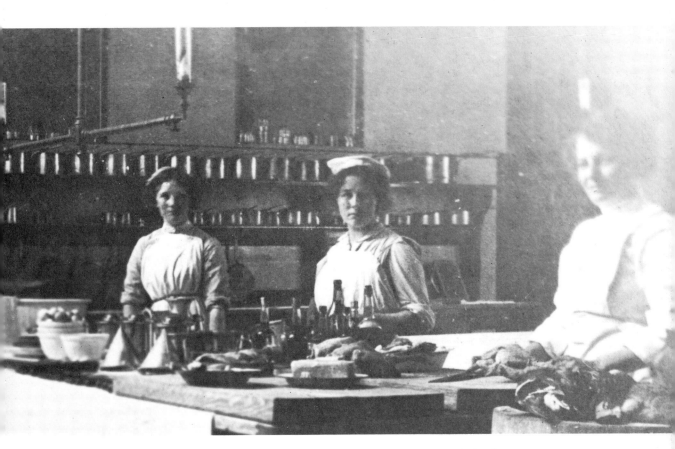

74 *Opposite page top left* The Fifth or "Yellow" Earl of Lonsdale, perhaps the most dashing personality in the Lake Counties of his day. Explorer and hard-riding horseman, the Earl succeeded to the title in 1882, when still in his twenties, and this portrait was made not long afterwards. He appears as an older man, accompanying the Kaiser, on p. 54. That picture is from the Earl's own collection, as are several more in this volume

75 *Opposite page top right* The Countess of Lonsdale, who accompanied the Fifth Earl in his explorations of the Rockies and the Canadian wastes in the 1880s.

76 *Opposite page bottom* Lowther Castle, now only a shell, was then a great country seat, and here is a house party in the grounds. The party includes several German noblemen (Count Metternich is on the extreme left, and Baron von Eckardstein is nearest to the wall creeper). In the front, centre, is the young Crown Prince Wilhelm. The Yellow Earl is discreetly at the back, next to the Baron

77 *Above* In the kitchen at Lowther Castle near the turn of the century. The great houses gave considerable employment to local people, and most of the "domestics" came from the country districts nearby. (The contrasting pictures are reproduced by courtesy of the present Lord Lonsdale)

78 J. J. Spedding, as a Colonel of the local militia, on his horse Cornet. (J. H. F. Spedding collection)

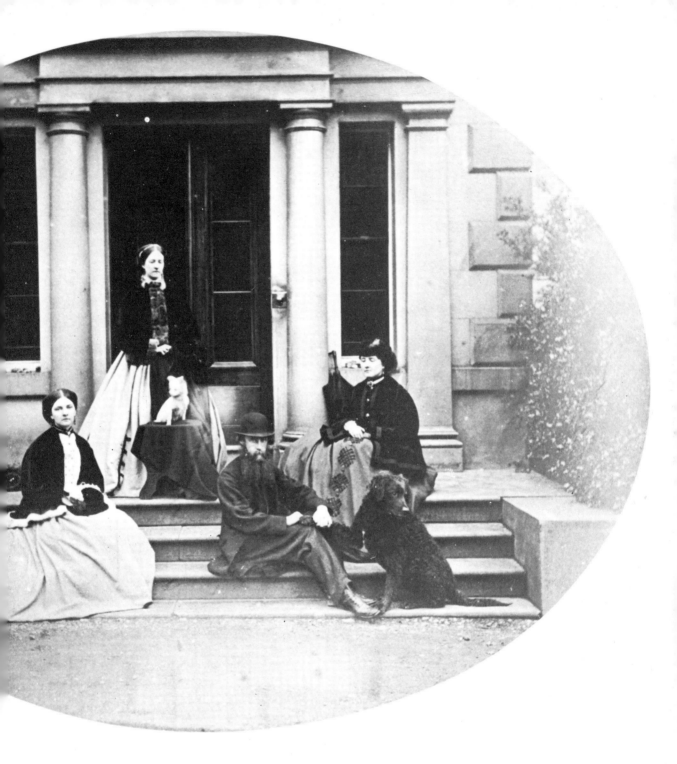

79 An early Victorian posed
study at Windebrowe, near
Keswick, showing John James
Spedding of the noted Armath-
waite and Mirehouse family,
with lady relatives. (By courtesy
of Mr J. H. F. Spedding)

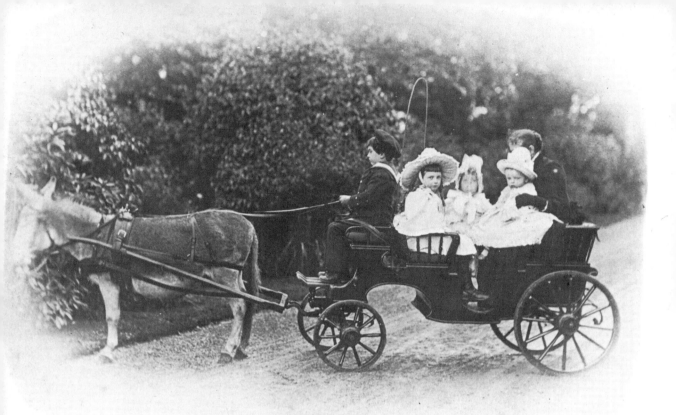

80 *Above* Spedding children with a donkey cart

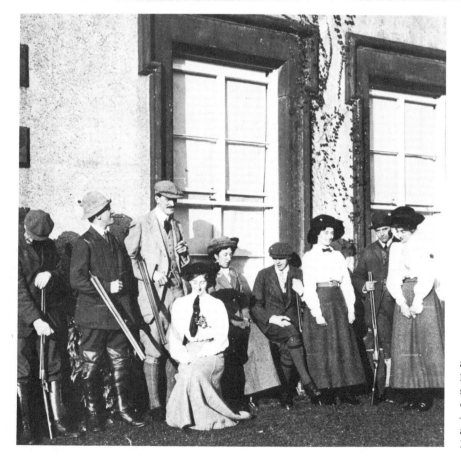

81 *Left* Mirehouse, near Bassenthwaite, the scene of this shooting party – with its distinctively Edwardian flavour – has associations with Carlyle and Tennyson. (By courtesy of Mr J. H. F. Spedding)

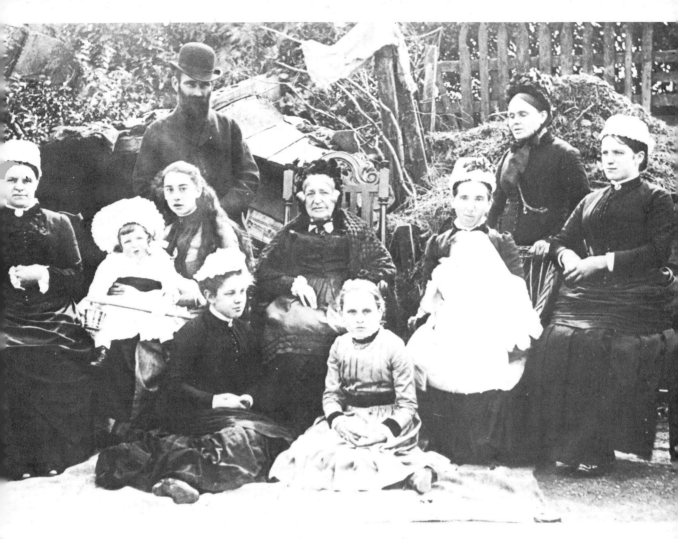

82 The Victorian house and garden staff at Mirehouse

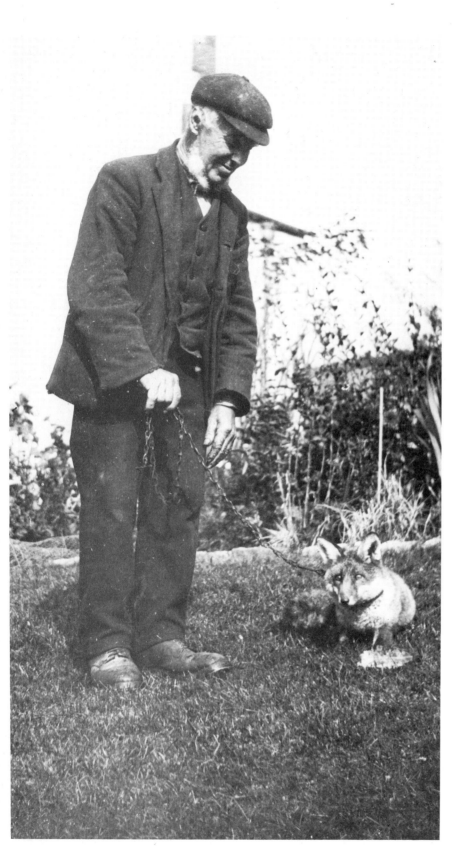

83 An "aristocrat" of a different stamp; Tommy Dobson, for years master of the Ennerdale and Eskdale foxhounds. Tommy died in April 1910, at the age of 83, and this picture was taken not long before his death. (From the M. C. Fair collection)

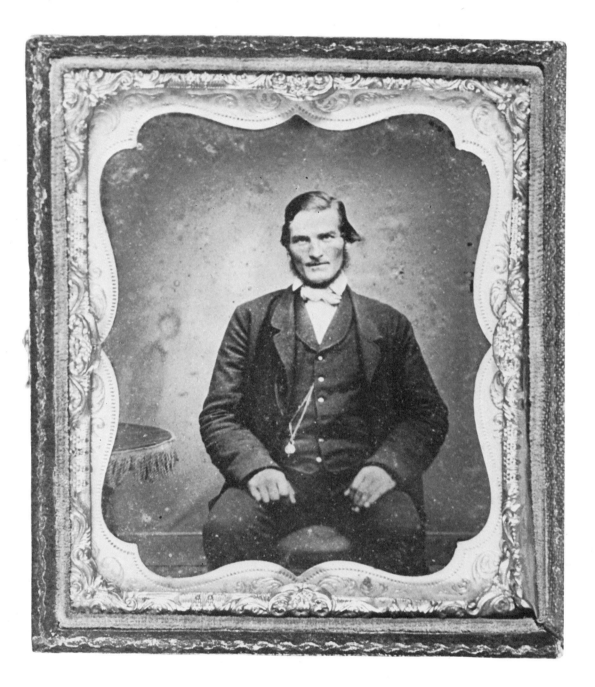

84 A Crosscrake (Westmorland) farmer, a portrait of about 1850. The shrewd, craggy features say much about this man's stock.

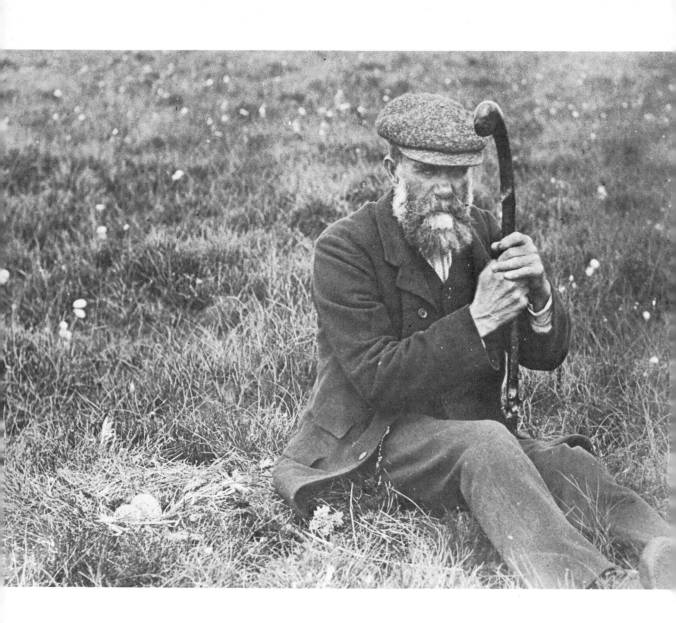

85 The keeper of the Ravenglass gulleries, about 1911 – a photograph by the late W. C. Lawrie

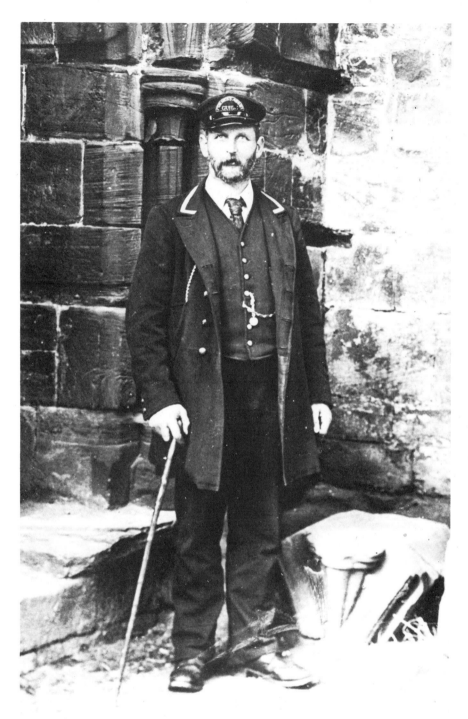

86 A Furness Abbey guide of Edwardian times

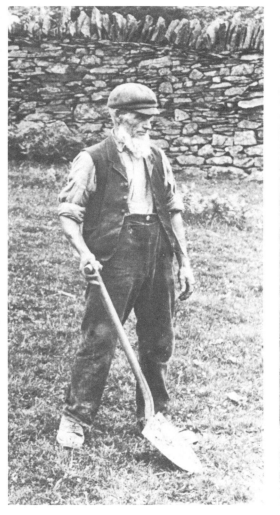

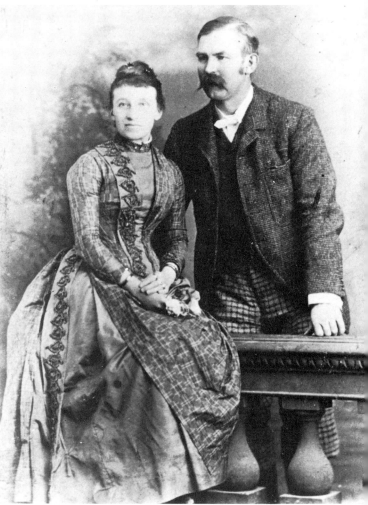

87 Tom Black, charcoal burner and woodsman, by the Sawrey woods about 1900. This study, carefully posed, is by a Bolton photographer, Harry Scholes

88 More Westmorland people; John and Fanny Airey of Old Field End, Patton. She died in 1882, aged 71, and her husband in 1885. Six of their children died between 1842 and 1871, and the survivors erected a monument to their parents

89 The oldest shepherd at Mardale meet – Isaac Cookson – a study by the late Joseph Hardman

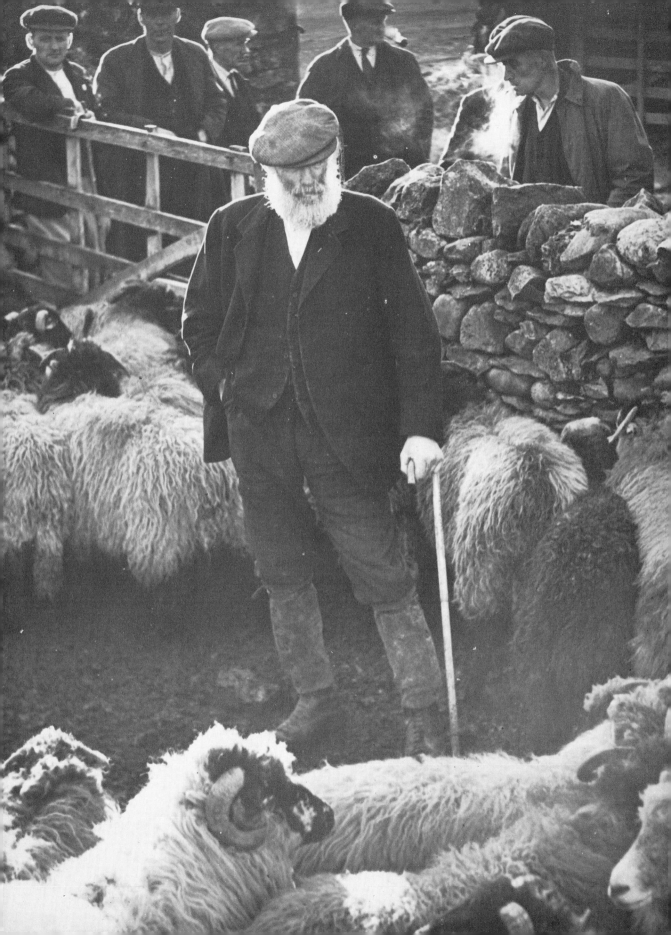

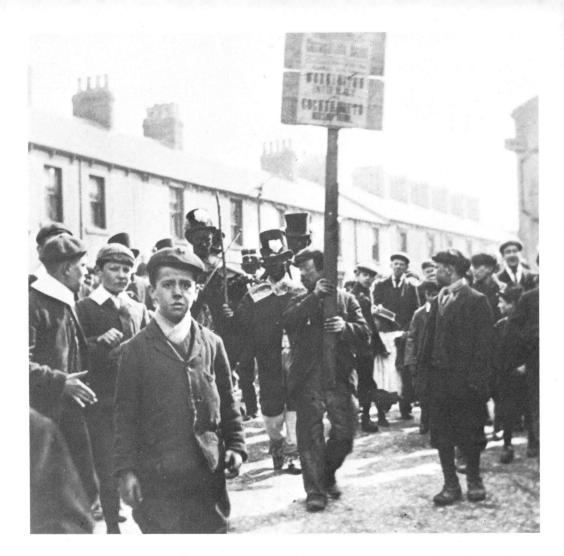

90 *Above* This picture, of miners collecting for charity at Workington around 1910, is by Mr W. L. Fletcher of Stoneleigh

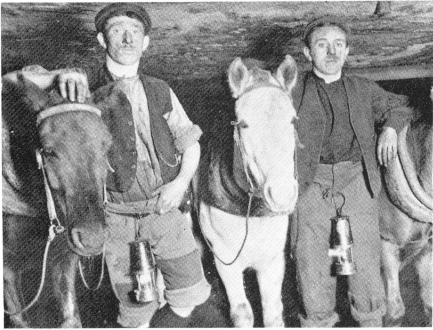

91 *Left* Putters – or pony haulage men – underground at Brayton Domain Collieries near Aspatria. This is from a postcard made by the Aspatria chemist (or pharmacist), Mr Joseph Pattinson, for the colliery company, during the First World War. The mining dress belongs to an earlier age

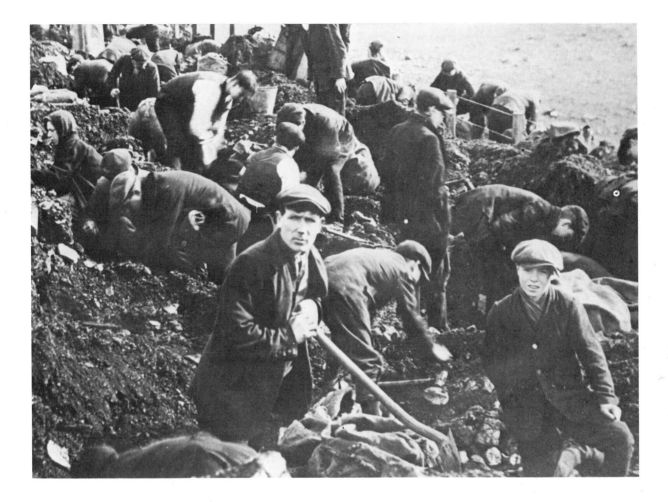

92 Miners on strike digging coal near Clifton, West Cumberland, in March 1912; a scene by
W. C. Lawrie

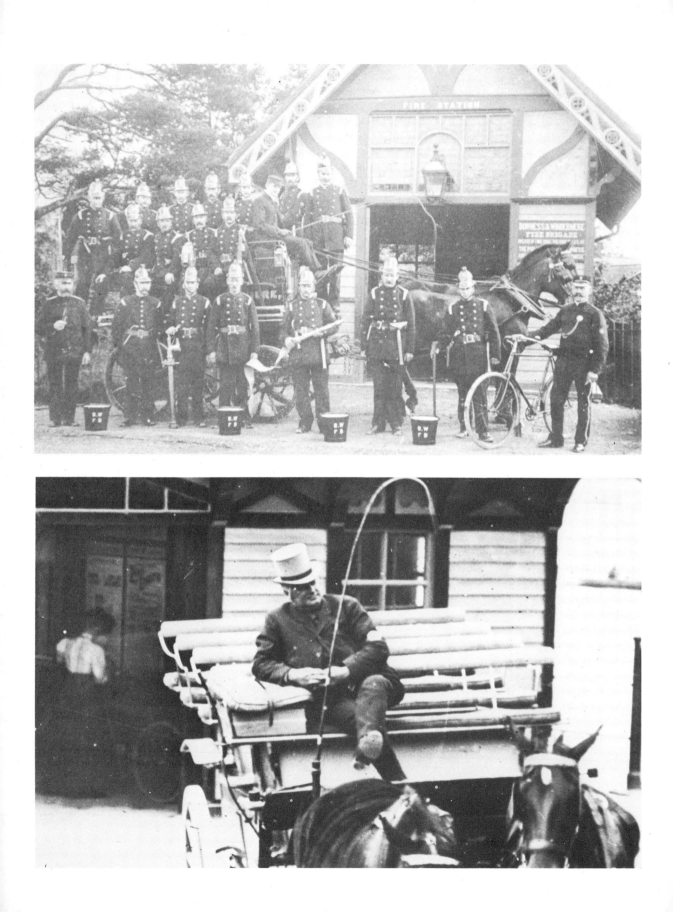

93 *Left* The Bowness and Windermere Fire Brigade and Engine at Windermere's Brook Road Station about 1880

94 *Left* John Rigg with his horse char-à-banc at Waterhead, Ambleside, about 1900

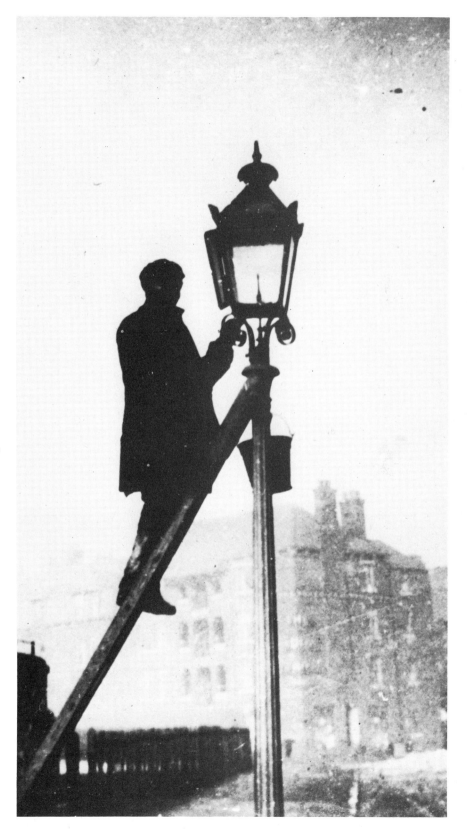

95 *Right* The once-familiar figure of the streetlamp cleaner near tenements at Barrow

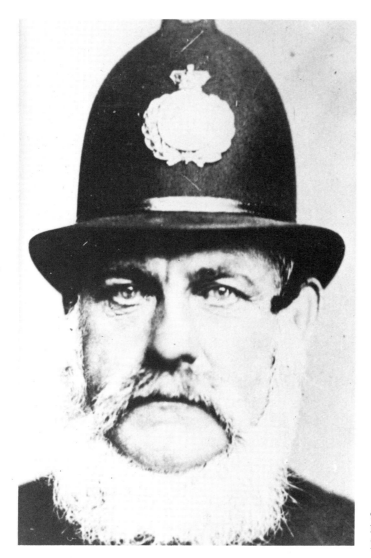

96 Thomas Greenbank, the
Bowness-on-Windermere
policeman, about 1870

97 *Right* Tommy Eccles, the Windermere and Winster postman, in 1869

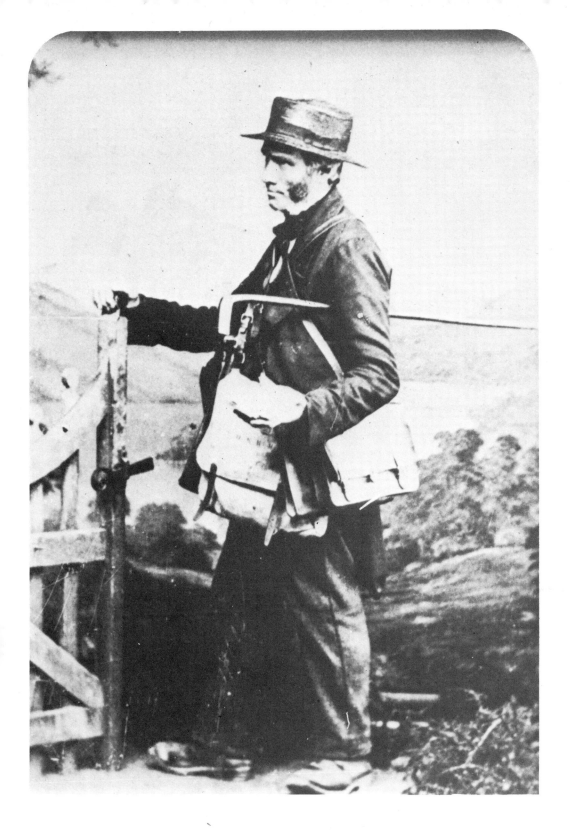

EARNING A LIVING

98 *Below* The boatyard at Arnside, Crossfields, produced the "nobbies" or Morecambe Bay shrimping vessels of the type shown here. Many were built in the nineteenth century, and their skilled navigators taught the Windermere yachtsmen to race

99 *Opposite page top* There was boatbuilding at Ulverston, too, and here are some mid-Victorian ship-carpenters about 1870. Much of the work was done at Saltcotes, not far from Conishead. These men carry the adze, the traditional tool for shaping beams and timbers.

100 *Opposite page bottom* These Maryport womenfolk are seen carrying away baskets of washing from the vessels which once filled the docksides (c. 1900). Next to the Queens Head is the provision shop of Margaret Sim; Mrs Jane Temple kept the Queen's Head

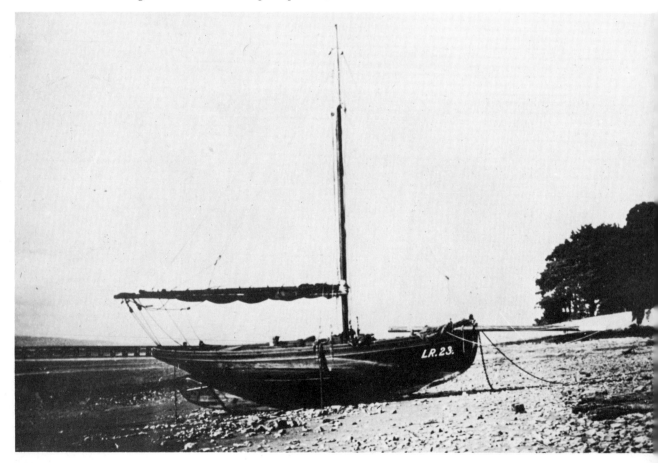

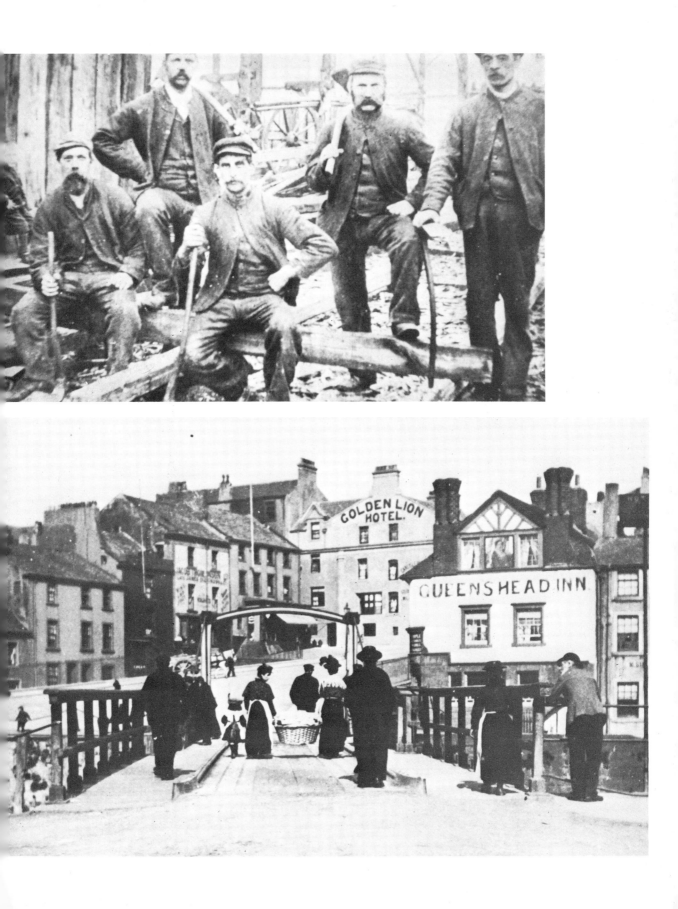

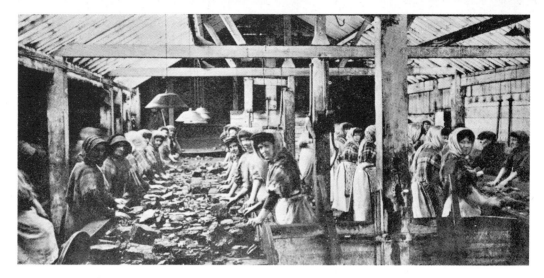

101 Pit-brow lassies on the "screens" at No. 4 Pit, Brayton, near Aspatria. Their job was to remove inferior coal and dirt from the conveyor belts.

102 *Below* This is probably one of the earliest photographs (*c.* 1860) of a Lakeland industry, the ore-processing plant at the Coniston copper mines, just below the valley of the Red Dell Beck, near the present site of the Coppermines Youth Hostel

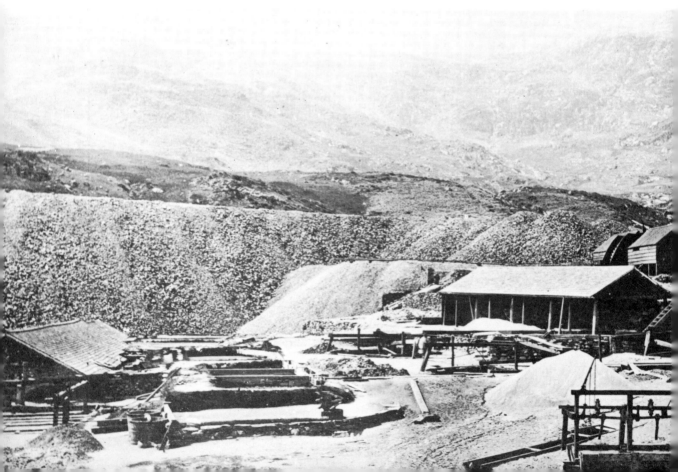

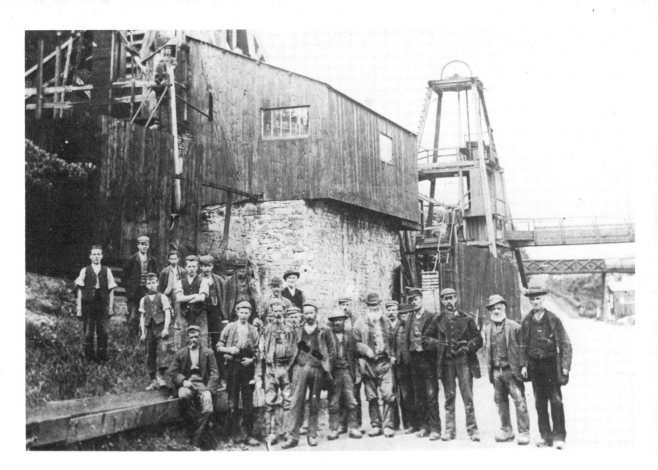

103 *Above* Workers at the lead mine at Thornthwaite, near Keswick, on the main Cockermouth road by Bassenthwaite. There are few signs of this mine today, and a garage is on the site

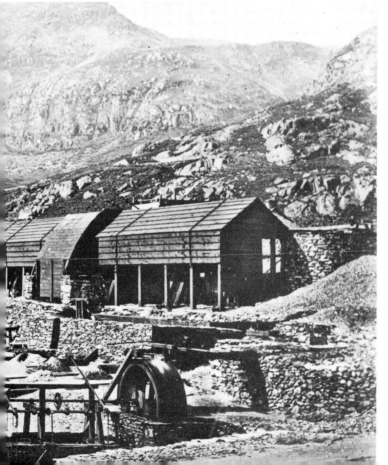

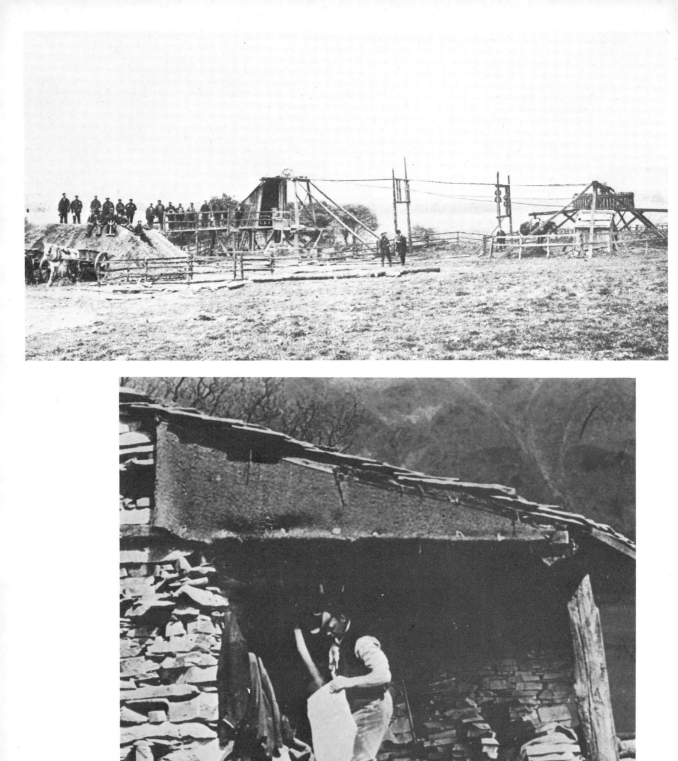

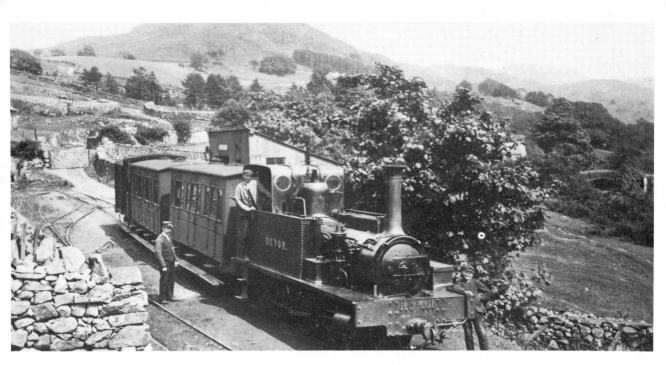

104 *Opposite page top* This photograph, of operations concerned with Furness iron ore mining (near Dalton), shows much more primitive machinery at work – the horse gin used for winding in the pit shaft.

105 *Opposite page bottom* Many dalesmen found employment in the slate quarries, like those of Tilberthwaite. Here is a skilled "river" or slate splitter at work in his shelter

106 *Above* The famous Ravenglass and Eskdale Railway had its origin in local quarrying needs. Here is the locomotive "Devon" at Boot terminus in 1905

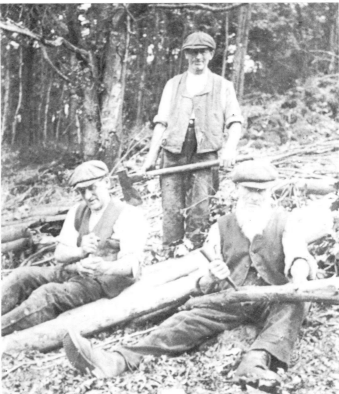

107 *Above* The woodlands of southern Lakeland provided work for many, although the demand for their bark, timber and charcoal was declining seriously when these pictures were taken. A woodland worker, Tom Black, with his sons Tom and Dick, in the woods near Sawrey about 1905

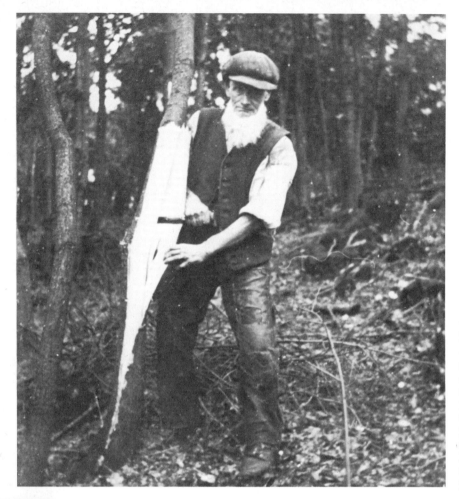

108 *Left* Mr Black is here shown posing in the act of bark-stripping, although the work was not usually done in this manner. The pose was for a Bolton photographer

109 *Below* Charcoal burning was once part of the life of the Lakeland countryside, and Arthur Ransome has immortalised it in *Swallows and Amazons*. This shows Sunday School youngsters posing on a partially completed cordwood stack (built on a ''pitstead'') prior to covering with fine soil and igniting through the central hole. The place – in the woods near Bardsea, about seventy years ago

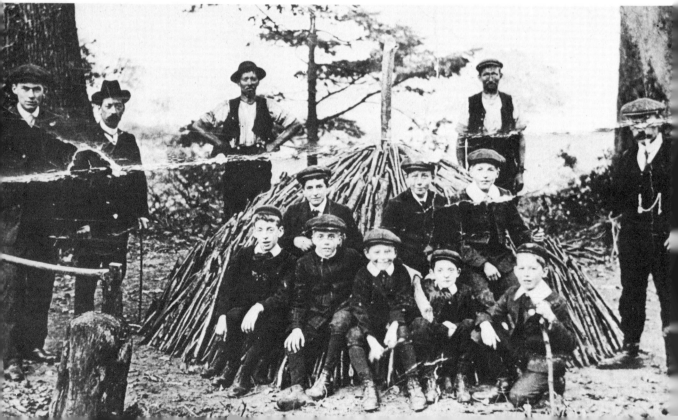

110 *Right* Lakeland woodland products were many, and the ash and birch timber was used for making bobbins for the textile industries. Here is a bobbin turner at Santon Bridge, engaged in hand-reaming with a parrot-nosed bit. There were scores of local bobbin mills in mid-Victorian times, but most had failed by the end of our period

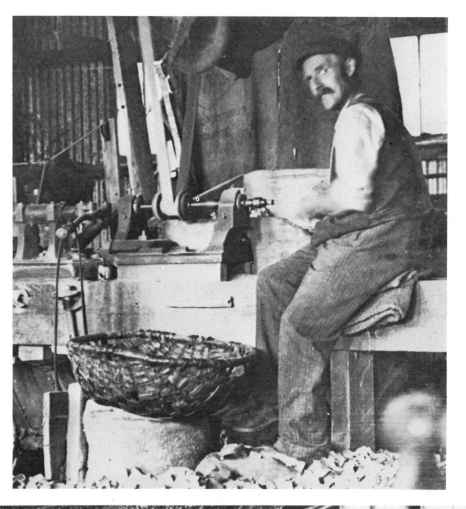

111 *Below* The previous plate indicates one use for the famous "swill baskets" of southern Lakeland. This shows the baskets actually being made by a group of "swillers". The picture itself is post-Edwardian, but the scene is typical of an earlier age

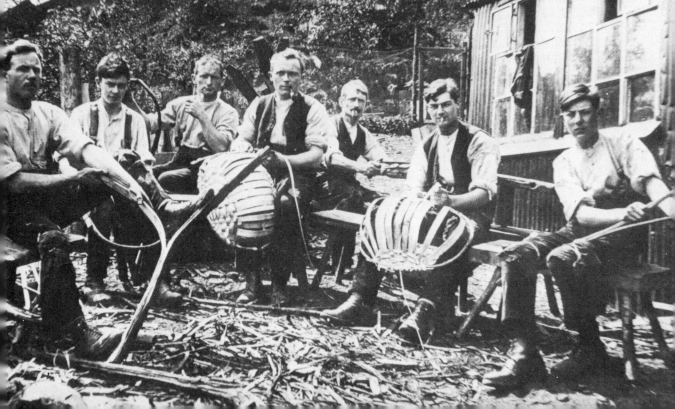

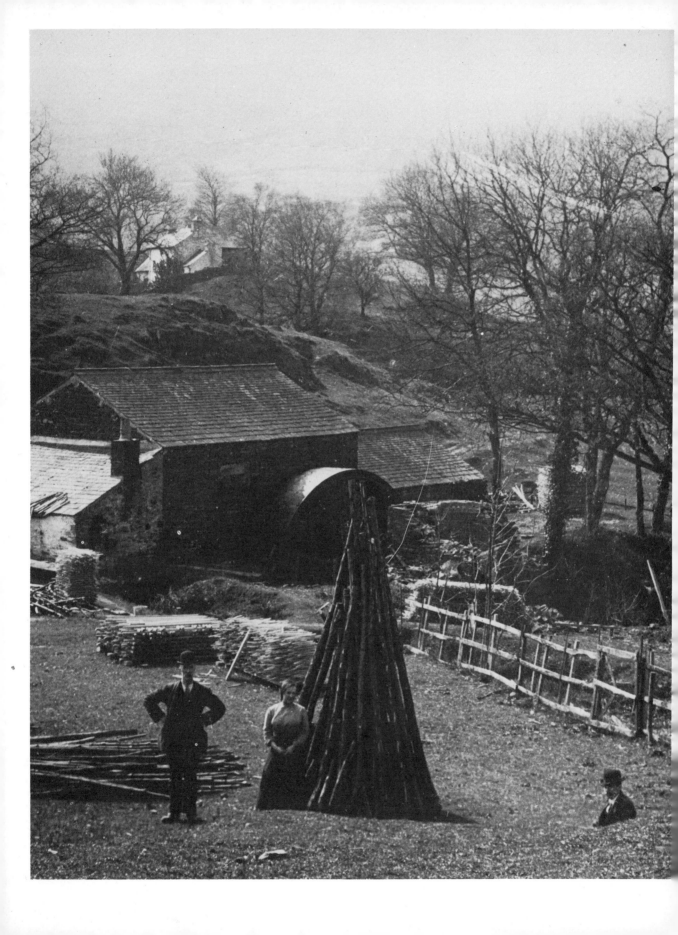

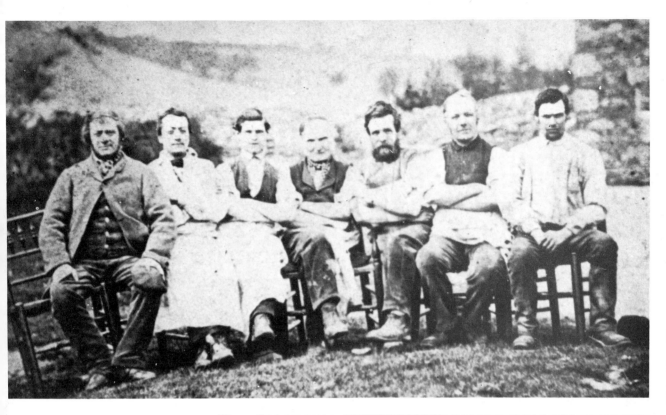

113 *Above* An old-established local woollen industry and its workers; the staff of the firm of J. B. Moore and Sons, drapers and woollen manufacturers, sitting outside their carding mill at Hallthwaites Green, near Millom, in 1872. The head of the firm is on the left

114 *Right* Hand-stitch men in the "K" Shoe Works at Kendal before 1914. These craftsmen stitched half-made boots. The taller member of the party at the back, Mr Fred N. Green-bank, worked at the factory for 28 years, and later worked at home making boots entirely by hand for £2.10s a pair

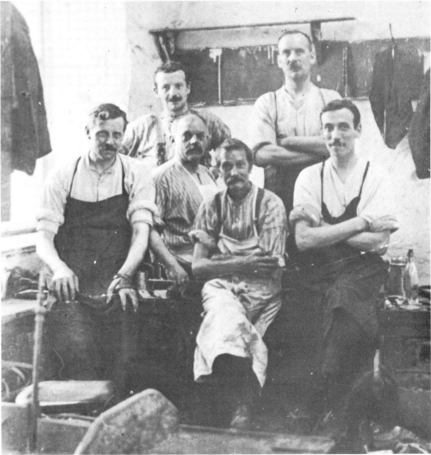

112 *Left* The sawmill at Broughton Mills as it appeared in 1905

THE LAKELAND FARMER

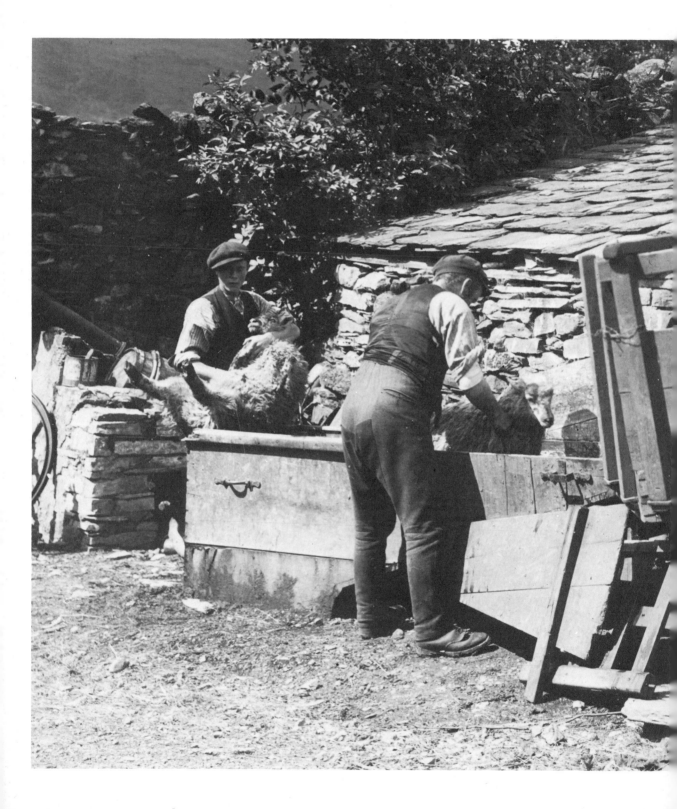

115　Sheep dipping at Kentmere about 1890. This picture shows the old-fashioned wooden dipping-tub and drainer in operation

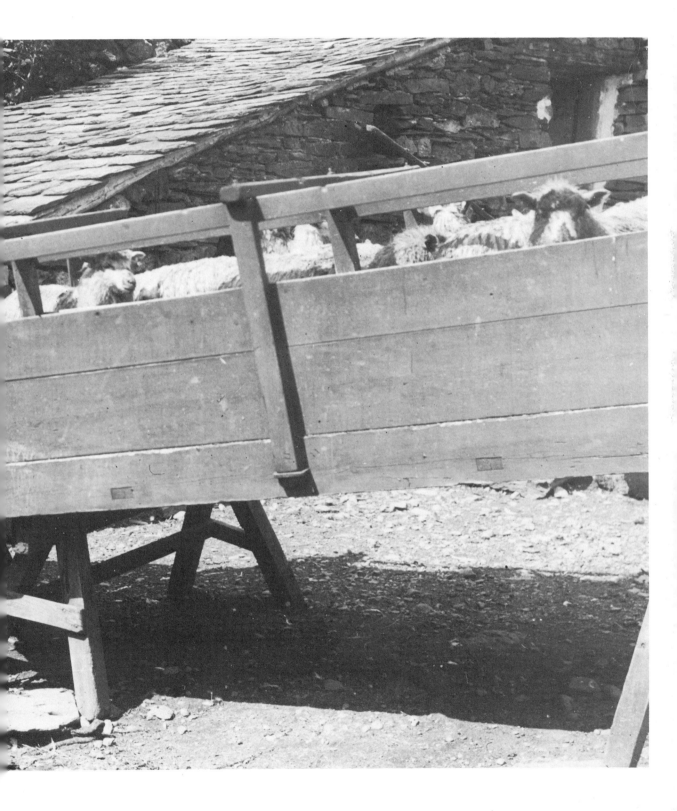

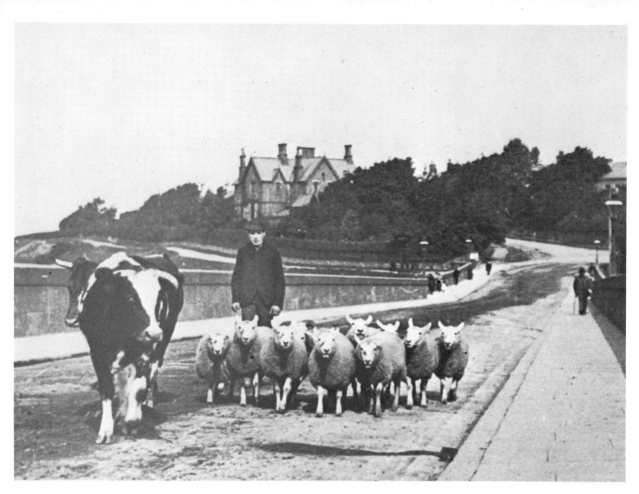

116 *Above* Driving animals over the Eden Bridge, Carlisle, to the cattle market on the Sands, 1898. The droving trade from Scotland had still not totally died

117 *Left* Another Carlisle scene

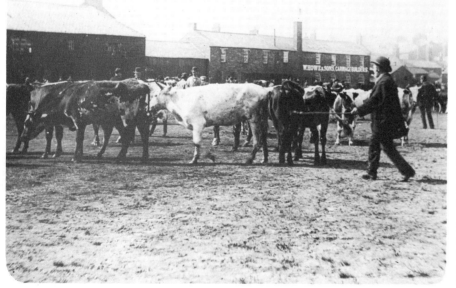

118 *Opposite page top* Sheep clipping on a Langdale farm. These were important social occasions: old friends came together, children carried salve for accidentally cut animals or bands to tie their legs. Later, the barn would be cleared for dancing

119 *Opposite page bottom* Steam threshing at Witherslack about 1910. Itinerant steam engines used to travel round the farms

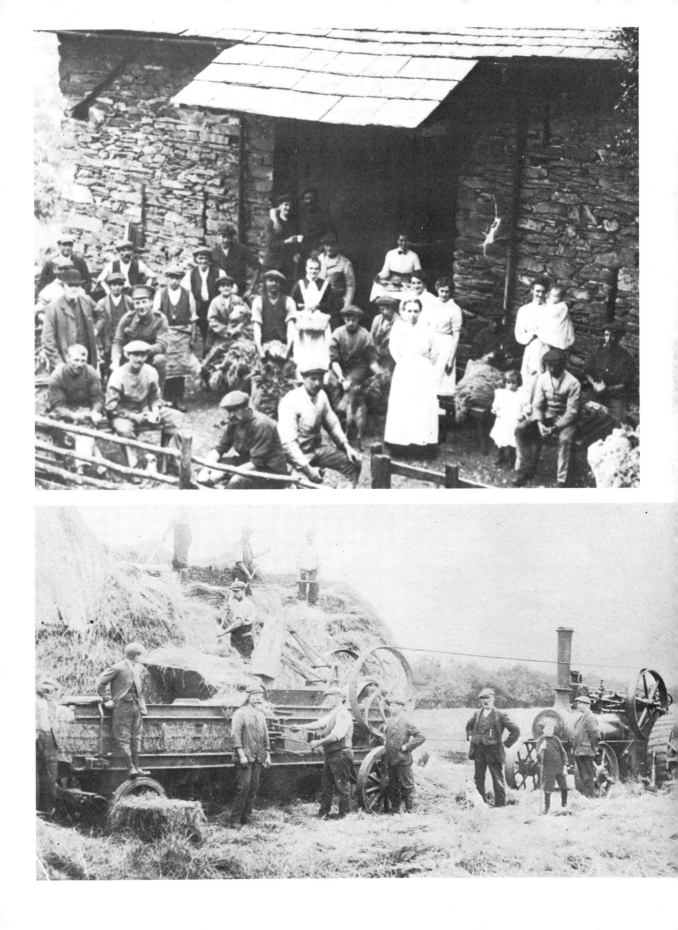

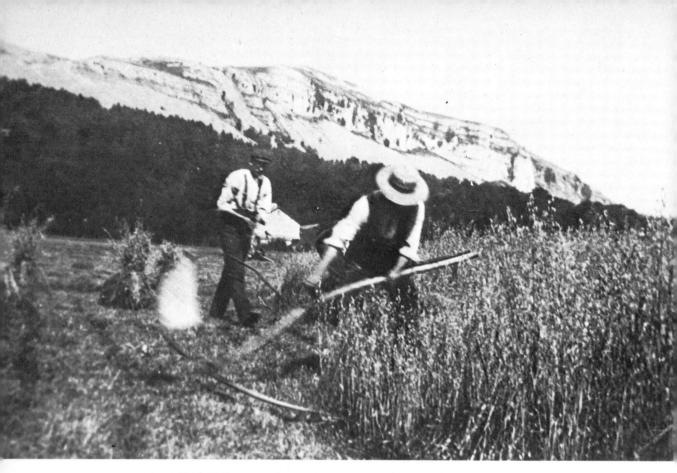

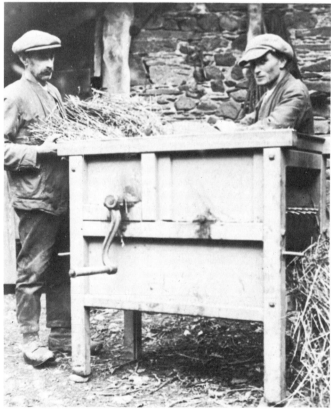

120 *Above* Mowing by the scythe near Whitbarrow Scar. This was a common way of cutting Lakeland oats crops for generations; the bent wand on the scythe pushed the corn up against the standing crop to make it easier to gather and bind. The cloth, which appears as a blur on this picture, assisted neat laying of the crop

121 *Left* Another old-established farming tool, going back over the centuries, was the hand-flail used in the barn during the winter months. In late Victorian times the simple peg-drum threshing or deeting machine took over. A deeter often provided the rhythm for a village barn dance. Here is a specimen from the Whicham valley

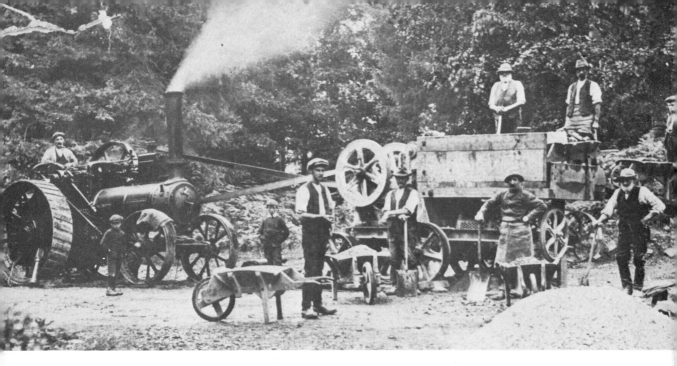

122 A traction engine driving a stone crusher at Hawkshead Hill, about 1905. The end-product was used for macadamising the roads before modern tarmac was employed. The itinerant driver, Mr Ellwood, was born in 1855 and died in 1937

123 The farm servants, living-in labourers who did most of the agricultural tasks in Lakeland, were taken on for six months at a time at hiring fairs in town and country. These, too, were great social occasions. Here is the hiring fair at Lowther Street, Carlisle, before 1895, when the street was altered

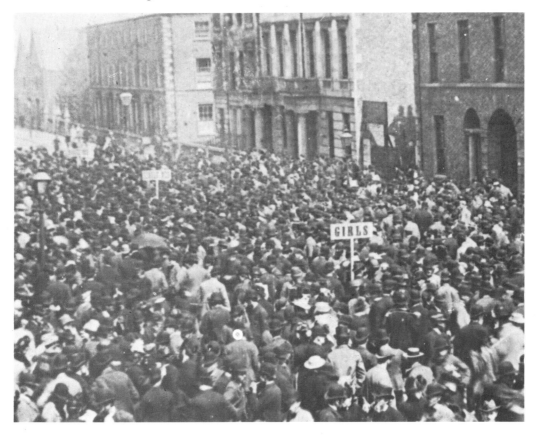

TOWNS: SOME CUMBERLAND SCENES

124 Although Carlisle became a great and thriving market centre for the Solway Plain and Vale of Eden, there was much deliberation and decorousness in its affairs; a view of Scotch Street about 1890

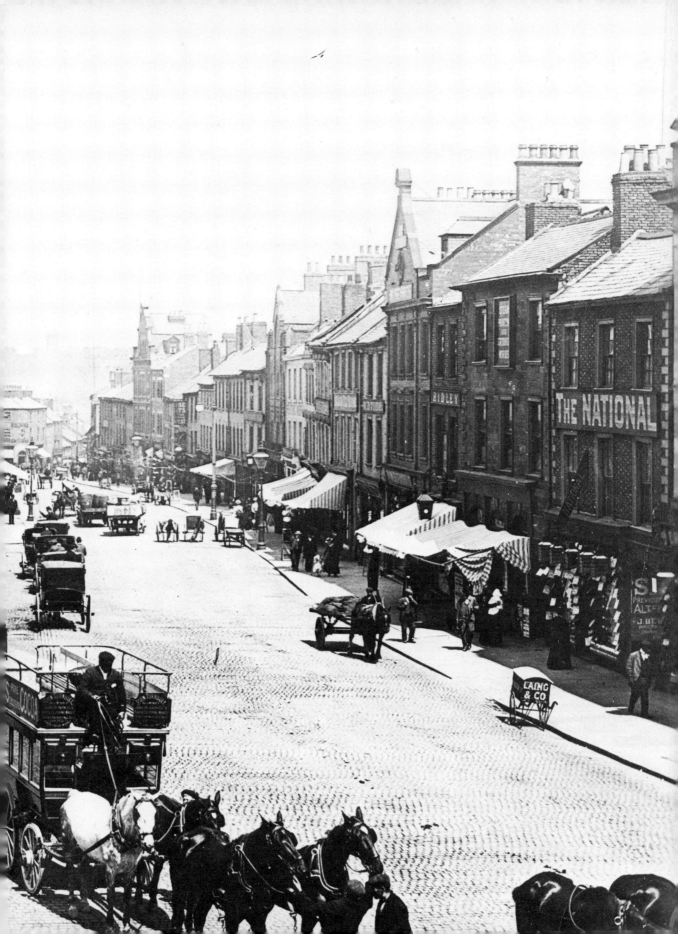

125 *Below* Rudd women at Carlisle Cross; ''rudd'' was a stone with iron oxide in it, and was used to rub stonework to give it a rich reddish hue

126 *Right* Victorian gentlemen in Carlisle market

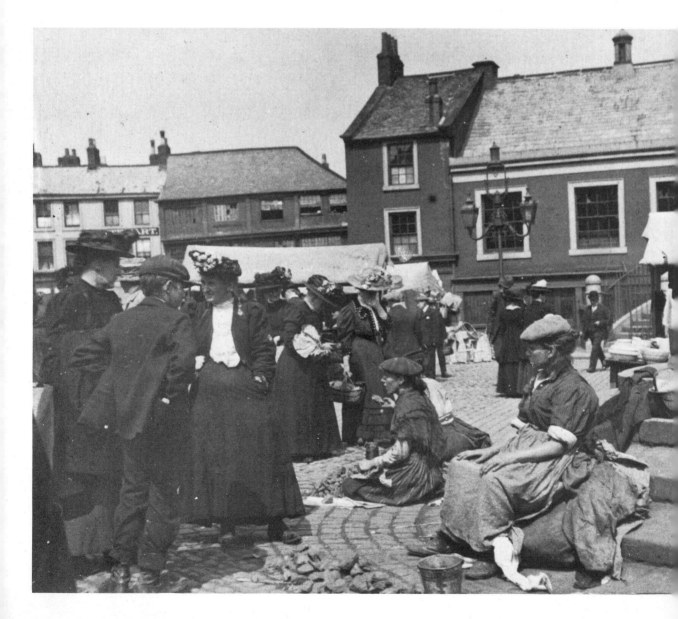

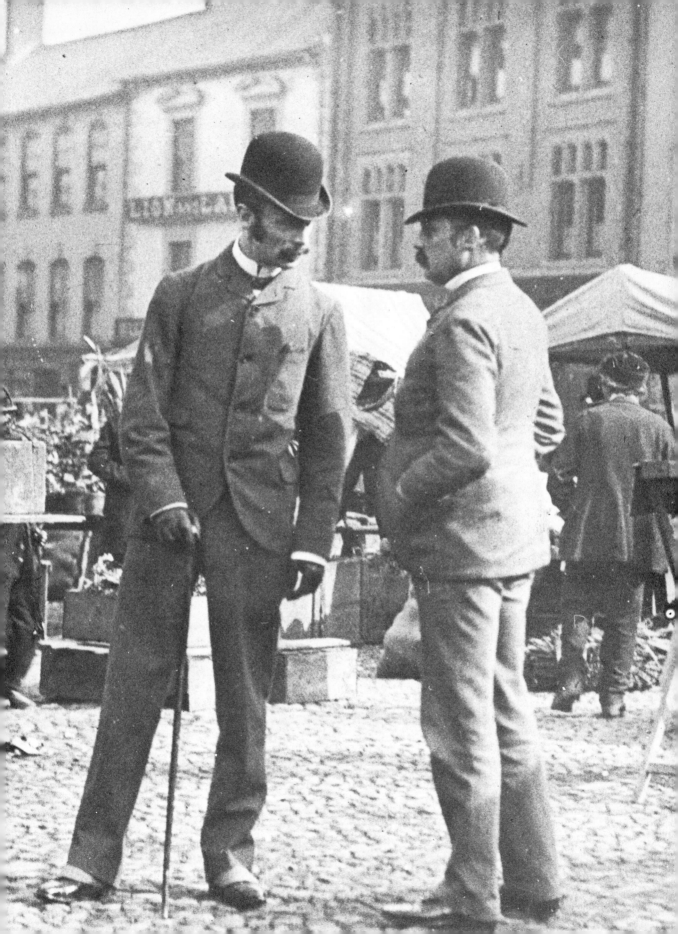

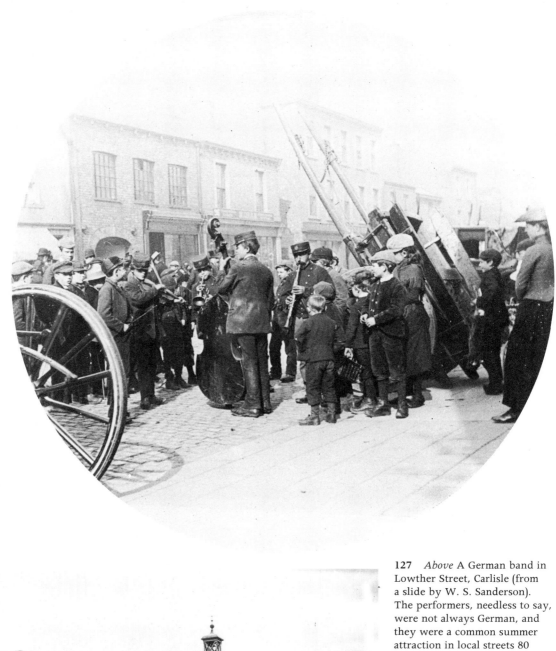

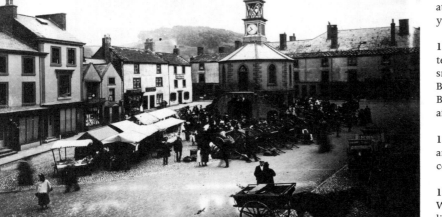

127 *Above* A German band in Lowther Street, Carlisle (from a slide by W. S. Sanderson). The performers, needless to say, were not always German, and they were a common summer attraction in local streets 80 years ago

128 *Left* Carlisle's influence tended to drain away that of the smaller local market centres like Brampton and Wigton. Brampton market place soon after 1900

129 *Opposite page top* Penrith, another diminished market centre, in 1891

130 *Opposite page bottom* Workington Harbour with local lighters and a paddle steamer

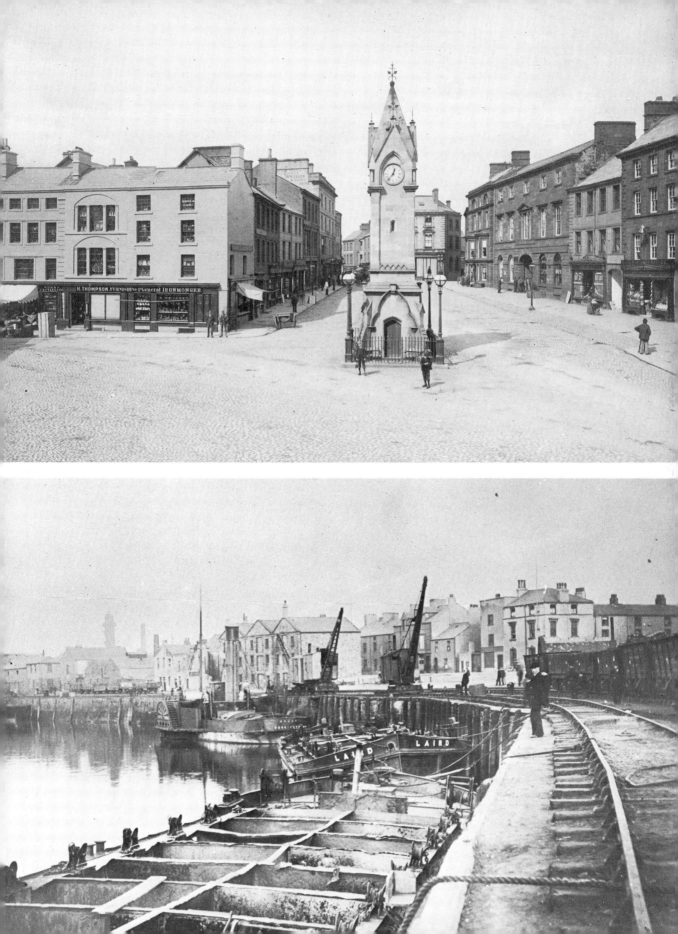

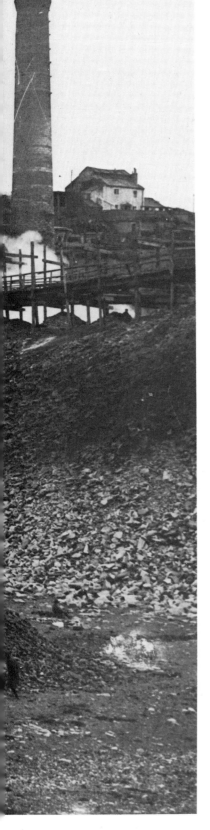

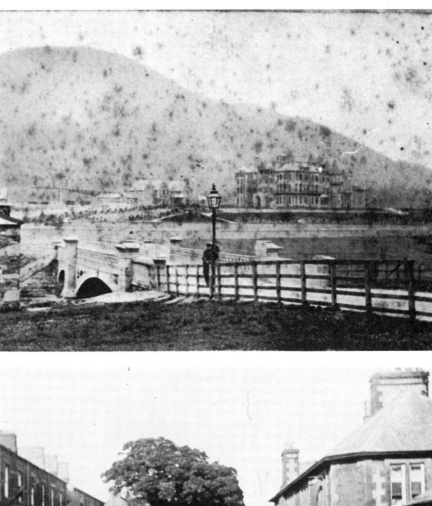

131 *Left* The famous Wellington Pit overlooking Whitehaven Harbour; this view of 1905 is now landscaped almost beyond recognition although the Candlestick chimney survives

132 *Top* A view down Station Road, Keswick, probably made soon after 1870. The Keswick Hotel, standing new and on its own here, was built in 1869

133 *Above* Merrymaking in Aspatria

TOWNS: WESTMORLAND AND LAKELAND LANCASHIRE

134 *Below* Yard 65, Stramongate, Kendal, one of many such hives of hidden activity

135 *Left* Highgate, Kendal, in the year of tragedy (1914). How many lives in this street were to be shattered?

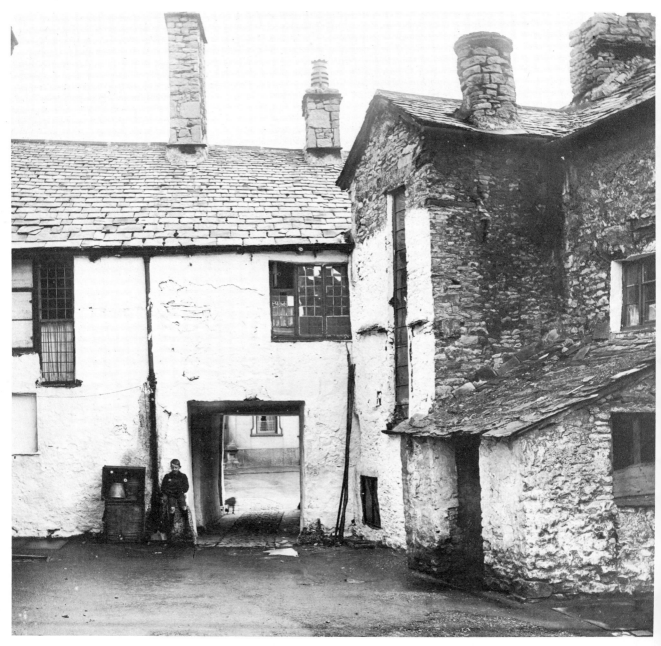

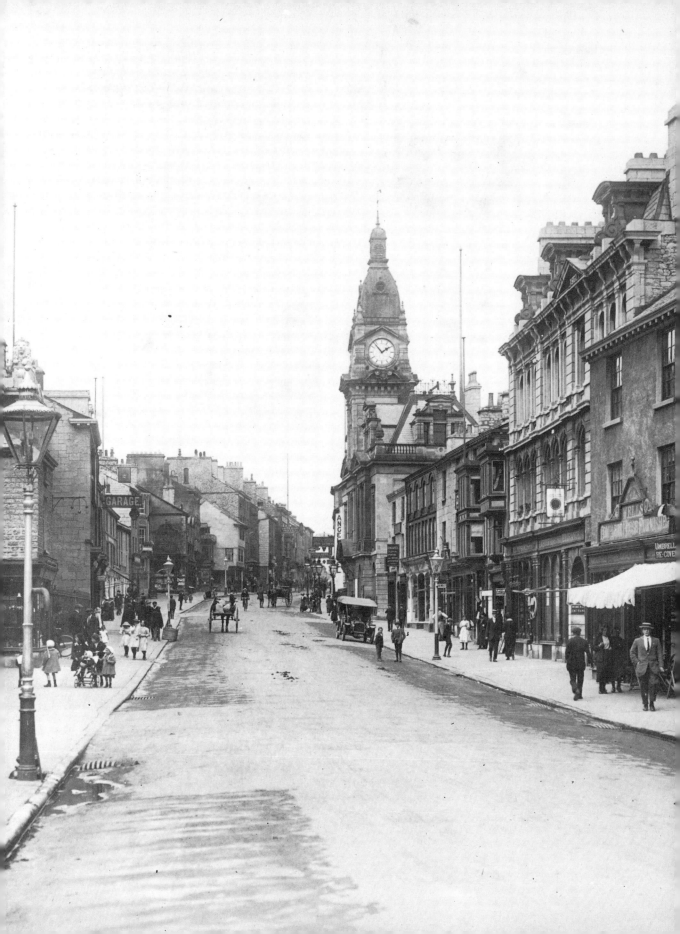

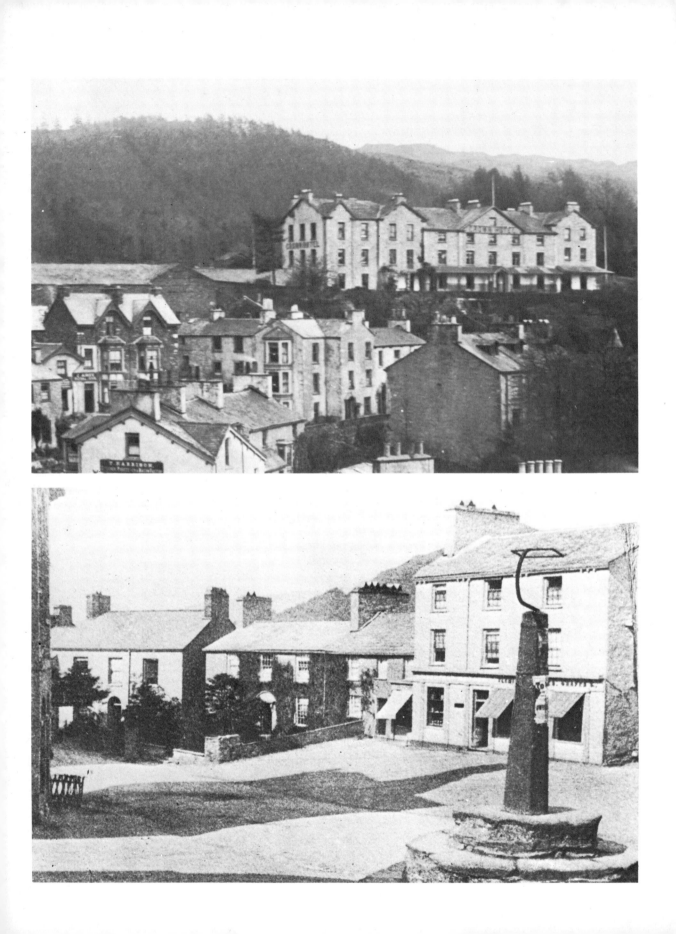

136 *Left* An early view of
Bowness (1868), taken from the
church tower, and showing the
Crown Hotel in its mid-
Victorian glory

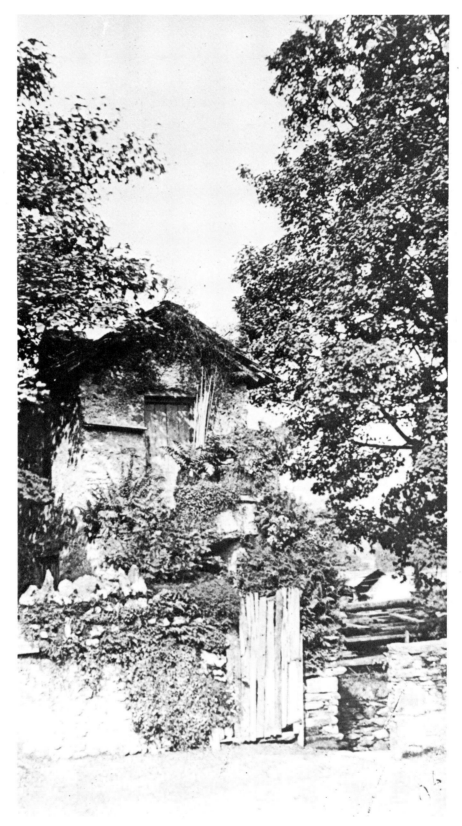

137 *Left* An Ambleside view
of the same period

138 *Right* The Bridge House,
Ambleside, as it used to appear

139, 140 Two Grange-over-Sands scenes caught well before the motor age had begun to wreak its effects

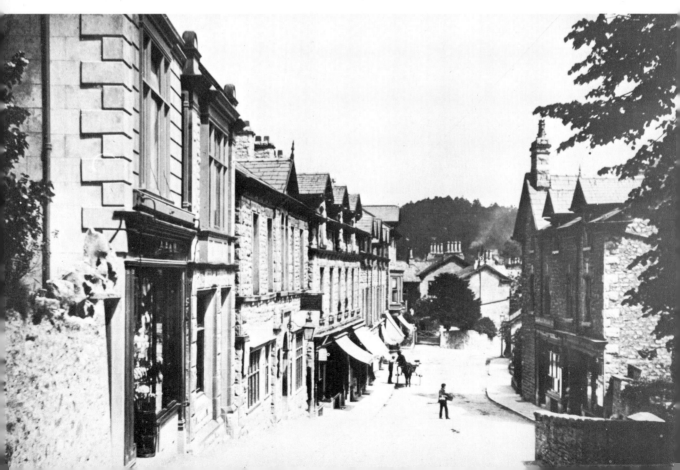

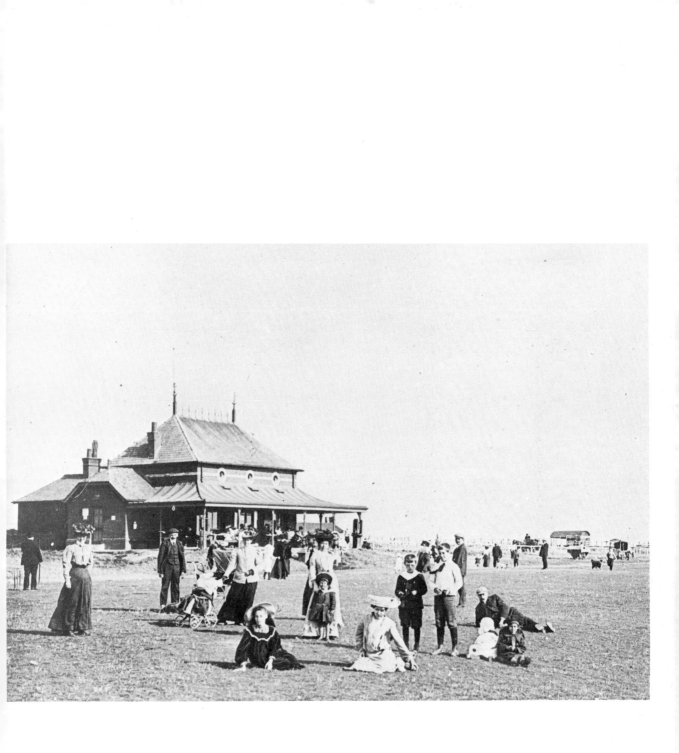

141 Edwardian relaxation could pervade even hardworking Barrow at holiday times. Biggar Bank, Walney Island

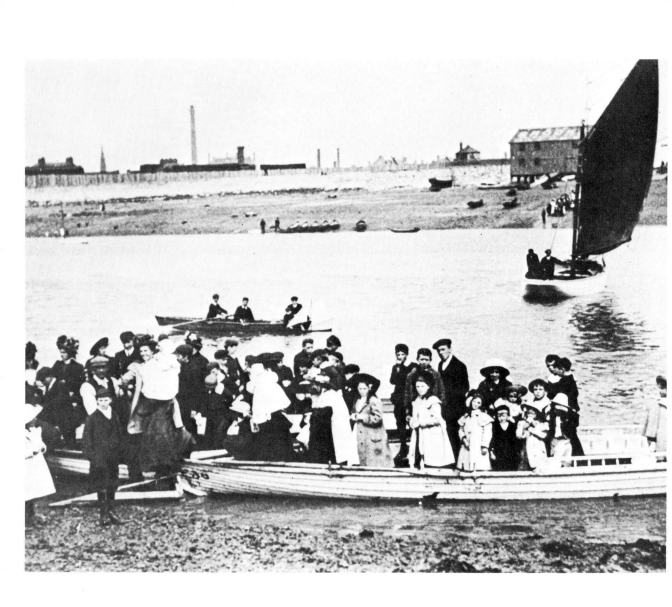

142 Crossing the Walney Channel (Barrow) by boat instead of bridge. The present bridge was built in 1905

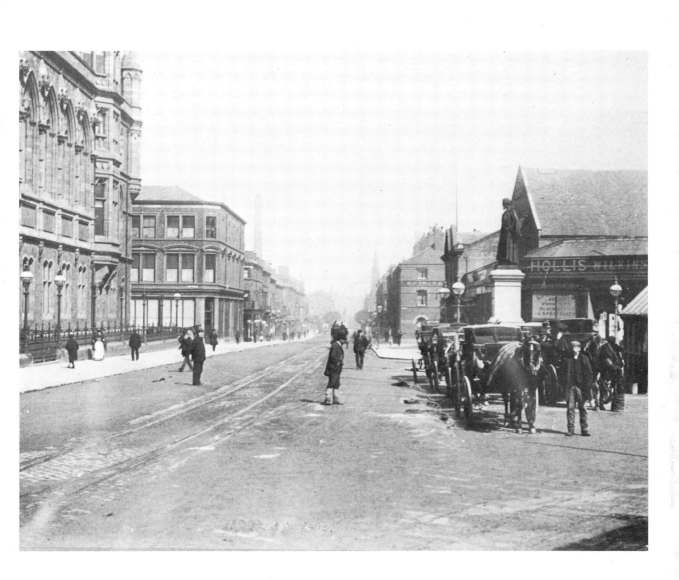

143 The leisured atmosphere is to be felt even in Barrow's Duke Street, about 1906

SOME VILLAGE SCENES

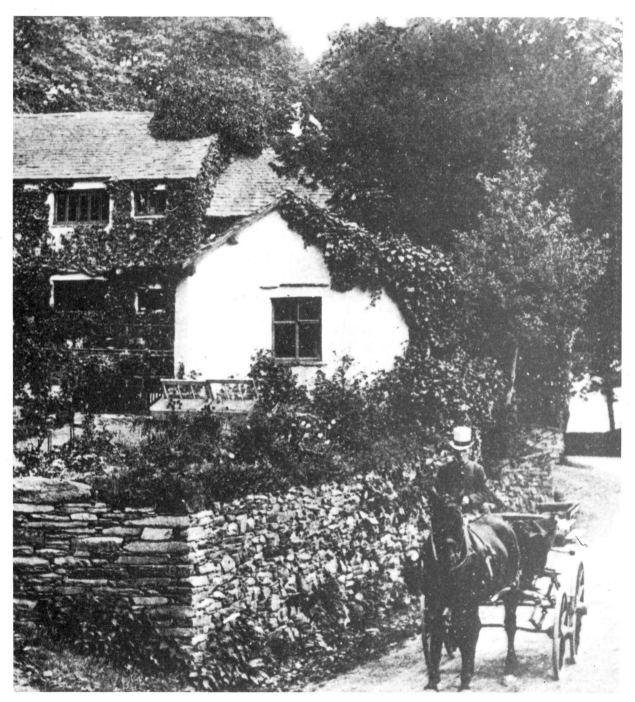

144 *Above* Town End,
Troutbeck (Westmorland), when
it presented a very different
appearance about 80 years ago

145 *Right* Troutbeck church in
the same period

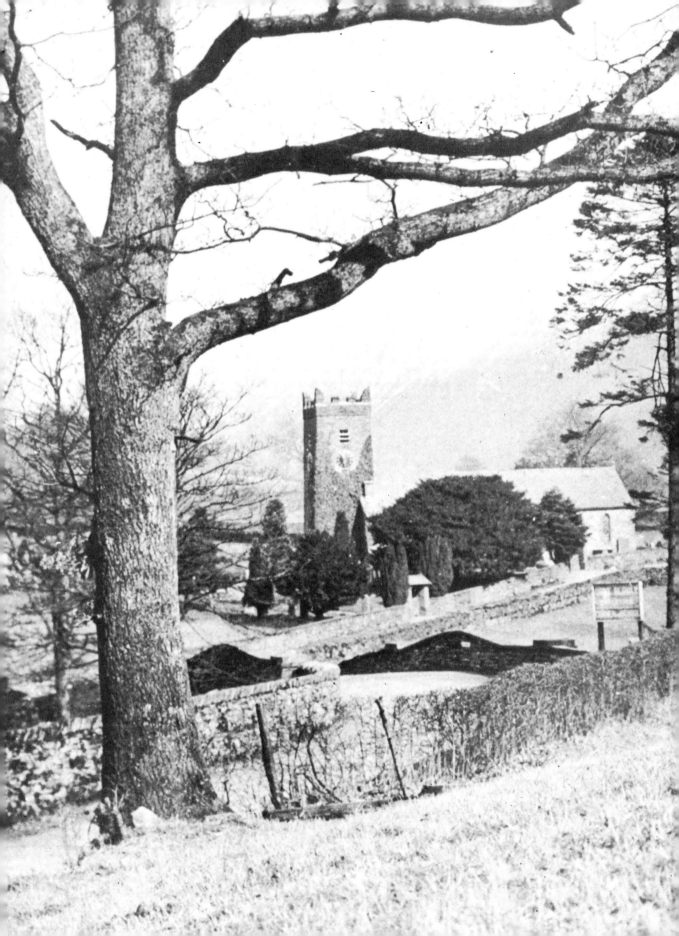

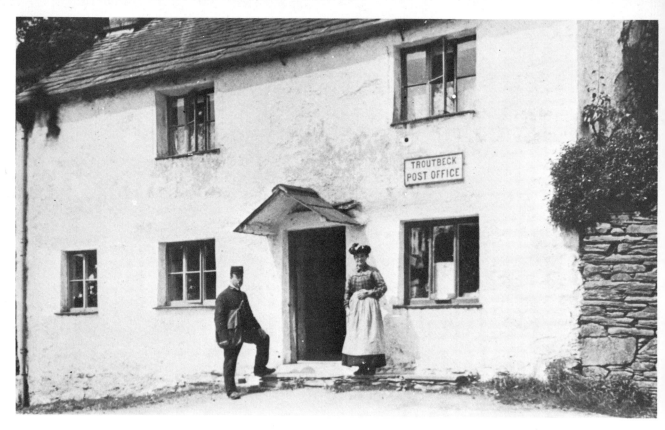

146 The Troutbeck postman and postmistress

147 Cartmel Gatehouse

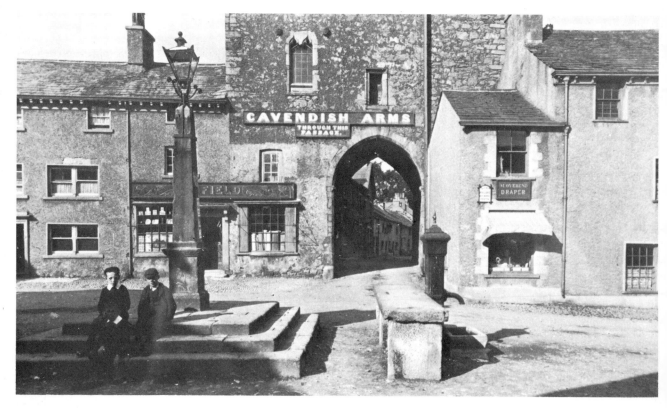

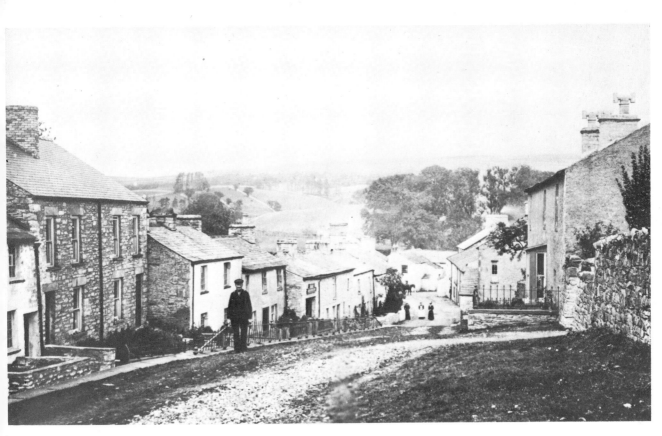

148 Looking down the village street at Ravenstonedale; a photograph by E. Yeoman of Barnard Castle

149 A Congregational chapel celebration at Ravenstonedale

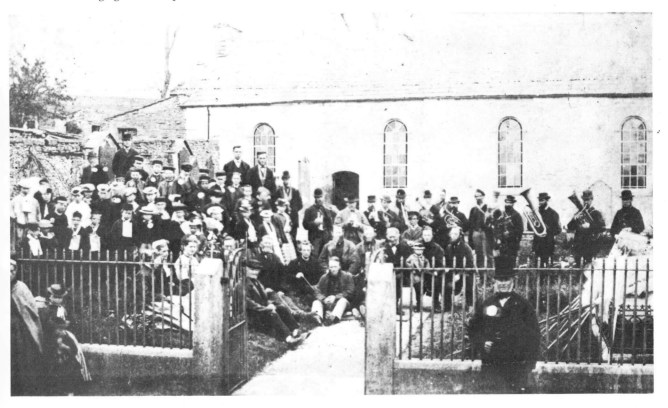

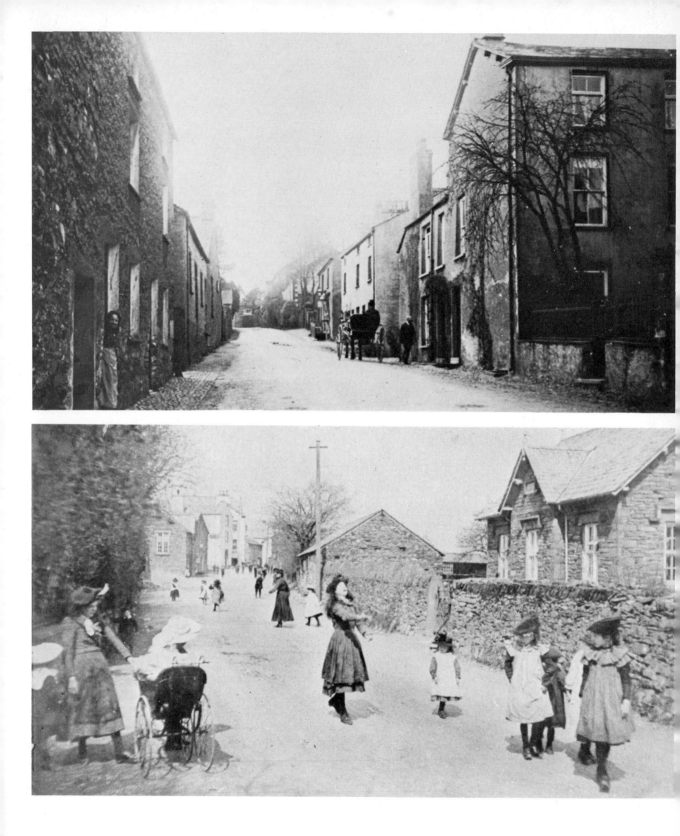

150 *Top* New Street,
Broughton-in-Furness, in
Edwardian times

151 *Above* A Hawkshead
childhood

152 *Right* Flag Street,
Hawkshead

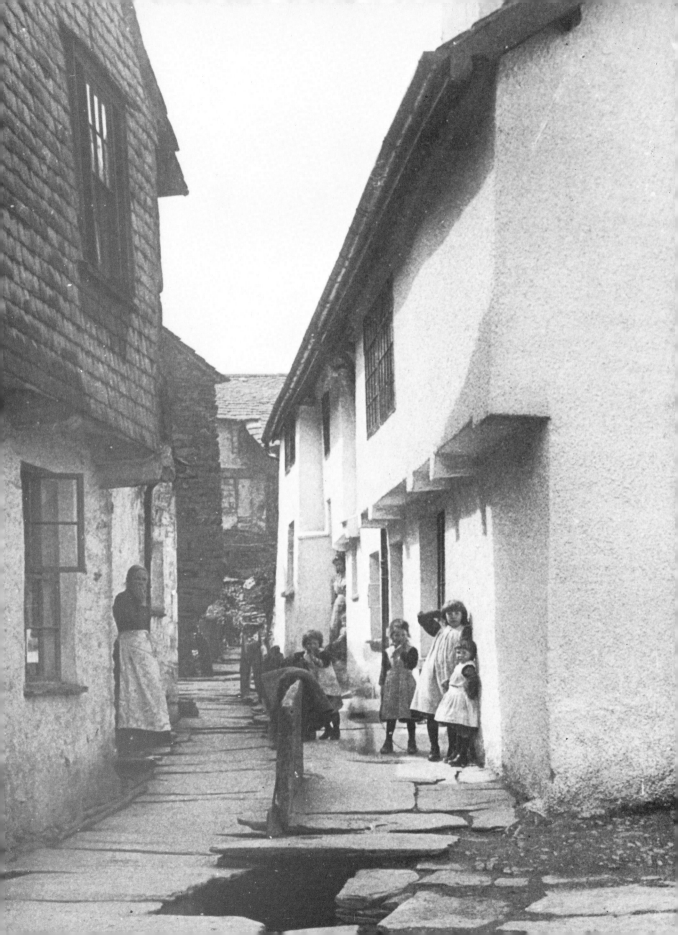

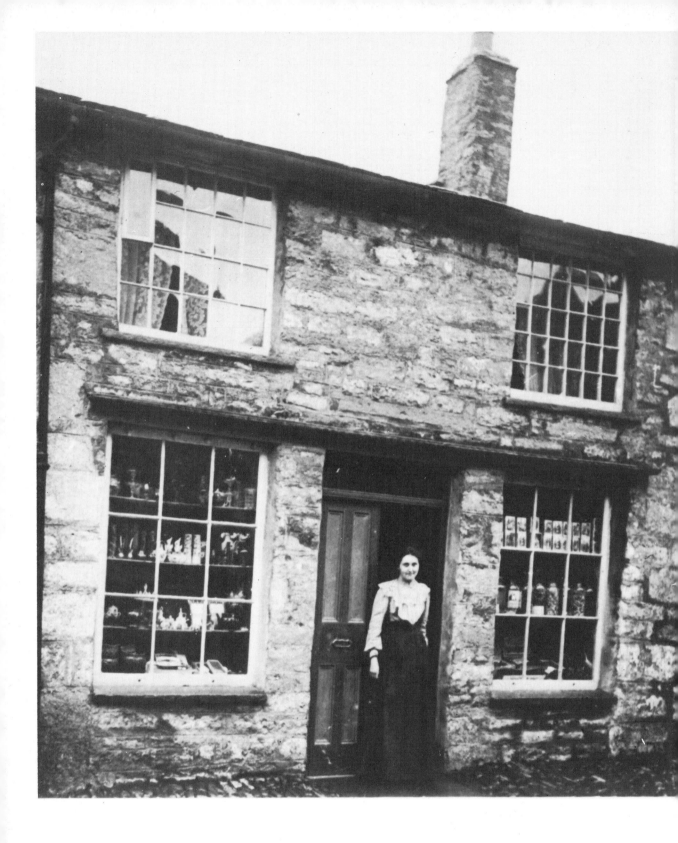

153 The shop at Ravenstonedale